WHERE FIRE SPEAKS

WHERE FIRE SPEAKS

A Visit with the Himba

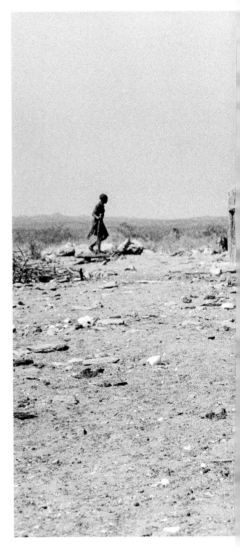

photographs by
DAVID CAMPION

text by
SANDRA SHIELDS

with an introduction by
HUGH BRODY

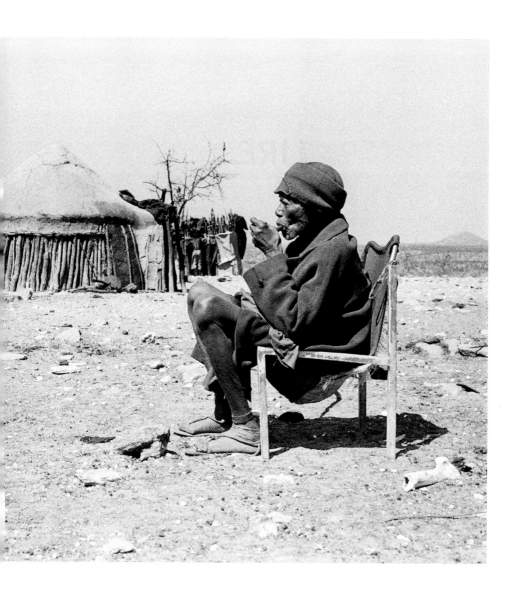

WHERE FIRE SPEAKS

A PARALLAX book from
ARSENAL PULP PRESS
103-1014 Homer Street
Vancouver, B.C.
Canada v6b 2w9
arsenalpulp.com

The publisher gratefully acknowledges the support of the Canada Council for the Arts and the British Columbia Arts Council for its publishing program, and the Government of Canada through the Book Publishing Industry Development Program for its publishing activities.

Book and cover design: Solo
Editing: Stephen Osborne
Cover photographs: David Campion
Printed and bound in Canada

NATIONAL LIBRARY OF CANADA
CATALOGUING IN PUBLICATION DATA:
Campion, David, 1965-
 Where fire speaks

 (Parallax)
 ISBN 1-55152-131-8

1. Himba (African people)—Pictorial works. I. Shields, Sandra, 1965-
II. Title. III. Series: Parallax (Vancouver, B.C.)
DT1558.H56C35 2002 968.81'0049639 C2002-910928-0

Where Fire Speaks

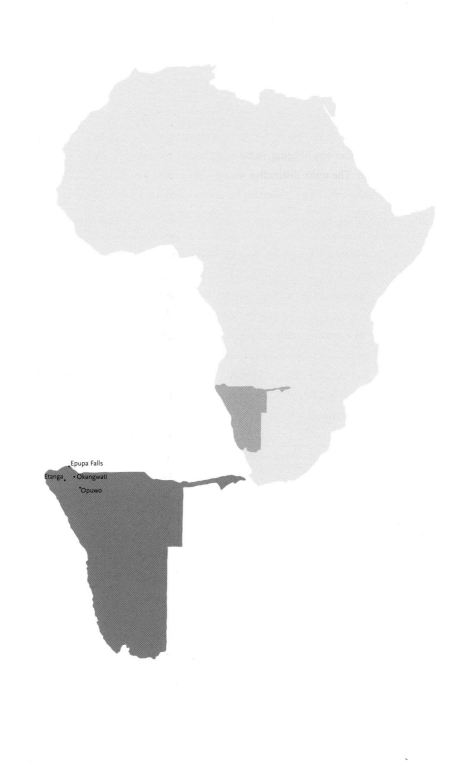

Epupa Falls

Etanga • Okangwati

• Opuwo

Hugh Brody

Just about all human beings live with pressure: pressure to be ourselves; pressure to be more like someone else. The poorer we are, the more we are likely to feel pushed and pulled towards another way of being, some other, more secure way of getting the things we need and want. The more distinctive we are – the more rooted in an ethnic, racial, or religious identity – the more important it may seem to us that we hold on to who we are, or who our ancestors have been. Modernity – the global economy, homogenized values, freedom to move to where the money is – has intensified this split between the self that has roots in the past and the self that could, or must, belong in the future.

For tribal and indigenous peoples, this split is at the center of their lives and politics. The pressures can be extreme. A sense of self comes from community lands, shared history, defining myths, distinctive clothes, ways of raising children, a language. To lose these, they say, is for such people to lose their place in the world, their links to *their* heritage and, all too often, their rights to their own resources. The tribal world has its own kinds of wealth – in the form of high quality food and the wisdom to live in a sustainable economy. Yet the lack of European goods and technologies means that they are seen as very poor – at least by the standards of those who hold the power in the world. Hence the pressure to become more like someone else – farm workers with regular wages, men and women with "good" educations and "true" religions who wear "civilized" clothes and follow the rituals of those with the wealth. And a hope or a dream – these can be pressures too – of the tribal child of today becoming the truck driver, shopkeeper, politician, pilot, and doctor of the future. The two kinds of pressures sit, of course, at the center of arguments about development. Everyone who is aware of land claims, aboriginal rights issues, and the struggle of First Nations to hold onto their lands and cultures has heard the arguments many times over. It is an argument that is as vociferous in parts of Africa as it is in Canada and the United States.

The Himba are a tribal group whose lands lie in northern Namibia, a region of arid scrub, thinly wooded hills, and the fertile edges of the Kunene River. They are pastoralists, moving herds of goats and cattle, following the changes of season and

climate, and using their distinctive understanding of land, animals, and their ancestors to live well despite the apparent harshness of their environment. The Himba have been among the most successful of African pastoralists, with large herds of animals and a secure economy in all but the worst periods of drought. They are seen as "poor" because of the relative simplicity of their technology and their appearance – the look of the "primitive" so fascinating to Europeans. So their real wealth is less important to outsiders than their appearance. This has two insidious consequences: they are deemed to need "development" because they are "poor"; and they themselves begin to believe they are poor, not counting their wealth in cattle and food so much as their lack of modern consumer goods and services. In the past twenty years, and especially since swapo came to power in Namibia and guerrilla war across the Namibia-Angola border ceased, the Himba have become a significant tourist attraction. They live in a spectacular landscape. They are beautiful, exotic, fascinating. Especially the women, whose braids, greased, and ochred skins and bare breasts are the object of intense interest – the focus of thousands of tourist cameras each year.

The look of the Himba and their lands has duly become a resource. Tourists negotiate a price with the women to photograph them in their Himba costumes, and with Himba families to photograph them at their fires, beside their mud-covered huts, dancing. That which is tribal (and therefore deemed to be "ancient" and "traditional") has monetary value. So this pressure to be the version of themselves that appears to exist outside modernity comes from modernity.

At the same time, Namibian politicians have been saying that the Himba must give up their old ways, and accept development. There are plans for a dam to be built on the Kunene River, at Epupa Falls. In the arguments these plans have triggered, ministers in the Namibian government say that the government is determined to bring "economic development to all our communities," and that the present lack of development in the Himba community "is a serious human rights violation." The Namibian Minister of Trade has observed that the Himba must "learn to wear shirts and ties and suits like me and everyone else." These are part of the pressure on the Himba to be more like other people – that is, more like those who are not so "traditional" and "poor" and "uncivilized."

So pressure on the Himba – on the one hand to look as Himba as possible, on the other hand to "develop" – comes from outside. Displays of wealth by tourists and images of modernity appear in front of Himba eyes just about every day of the year. These have their effect on how the Himba see themselves, and are their own kind of pressure, reaching from outside to inside the Himba world. There are also the wider, more general pressures that originate in two ideas – one about the future; the other about the past. Both these ideas are somewhat romantic – idealizations, perhaps, of economic and social life in which wishful thinking and naïve optimism shape the so-called facts. Those who want beautiful, bare-breasted Himba women for their cameras are not interested in the realities of Himba history (with its complicated changes of society and relations with neighbouring cultures); those who believe in "development" do not speak about the extreme poverty of the many in their societies who are displaced, landless laborers. Two kinds of romantic myth – the one of "tradition," the other of "progress" – dominate the arguments.

So what does the present, as opposed to fictions about the past and future, really look like? Who are the Himba of now? What is it like to travel there with a commitment to neither of the dominant forms of romanticism? David Campion's photographs and Sandra Shields' narrative – the two elements of this book – give answers to these questions. Two beautiful, laughing Himba girls, dressed in traditional clothes with their hair in magnificent braids, are at the center of one of the photographs; to the side, a little in the background, two tough-looking Himba youths, in western clothes, lean against a tree. In another photograph, a Himba woman sits in the foreground, but at the edge of the image: the rest is taken up by a group of white men repairing the engine of a jeep. Analogous juxtapositions appear in other of Campion's wonderful pictures. A Himba and a Herrero woman, both in the clothes of their cultures, are looking over the lingerie, shirts, and shoes on sale at a roadside store; a young Himba woman squats in the dark corner of a small bar, her back to a heap of Coke crates. In photograph after photograph the different, and perhaps rival, elements of the real world of the present day are there to be seen. And the reader has the sense that this is incidental, rather than some plan, some political aesthetic. The images have rival images because realities of the present just do rival one another in the Himba world – as they do in all our worlds.

But one of the most striking photographs of all in this book is the x-ray of a skull. A doctor holds it up to the light to look, thereby obscuring her own head. The head of the Himba whose skull is thus shown sits alongside, looking down, far away, being helped, yet seeming imprisoned. This is an image full of power – not because it is exotic, but because it is all too familiar. The helplessness as our head is taken into an x-ray, examined by a stranger, whom we can not know but on whom our very life may depend.

In this book, the text makes the same kind of journey as the photographs – into the complicated, puzzling real. Sandra Shields allows the reader to come with her, both in the detail of the journey and in the unease the journey can (and probably should) cause to the traveler. She describes the way tourists buy the right to take photographs, seeking the trophy to take home that snapshots are; and is aware that she is also there to visit and take something home. She speaks of the inequality that exists between tourists, their vehicles loaded with supplies and equipment, and the Himba; and tells of the repeated requests for things that the visitors have. But she includes herself in this narrative, so allowing us to experience, through her account, the inner discomforts of being the relatively wealthy visitor.

This is not a book that knows what is best for anyone, least of all for the Himba. It does not obscure the drinking, the begging, and the new great danger – of AIDS in a society that is less and less able to maintain sexual and social boundaries. It does not say the hydro project on the Kunene River is right or wrong. But it does voice a suspicion, which is implied also by many of the photographs, that the dam is as likely to be as destructive as it is beneficial to the Himba. The balance of these forces will depend not simply on whether or not it is built, but the way in which this is carried out. Development may have some chance of bringing benefits, but if, and only if, the land rights of those whose resources are being transformed are recognized. This is a book that makes a quiet, understated case for the Himba: the pace, scale, and process of development must be done with and for the Himba, as well for the nation as a whole.

David Campion and Sandra Shields now live on the west coast of Canada. David grew up in Africa, and first visited the Himba in 1988. They traveled to Namibia together in 1995, impelled to go when they learned about the possibility of the Epupa dam being built and reading the words of a Namibian official: "The Himbas don't want

to stay like baboons. They also want television and lights in their homes." They were funded by the International Center for Human Rights and Democratic Development. They wanted to see for themselves: was there a real threat to Himba well-being, to the lands on which they depended, to the ecology of one of Africa's wildest rivers? Or was there an authentic – an appropriate and necessary – development?

David and Sandra know from their own society what can happen to indigenous peoples when their lands are "developed." They have seen the price that the original owners and occupiers of the land often must pay for "development" – be it for forestry, farming, or hydro-electric power. Awareness of their own country may have helped them to see the realities of another. Namibia is far away from Canada, but the fate of the Himba may not be all that different from that of many, many other tribal peoples. The rights of peoples to live in security on their own lands, and their right to the resources that lie in and on these lands, have been violated again and again in the history of colonialism and development. Newcomers to frontiers determined to acquire land, ideologues determined to bring "civilization" to the "primitive," corporations intent on making profits from mega-projects, governments bent on modernizing their economies – these are forces in the modern world that speak of the good they can achieve while failing to recognize the harm that is done to some of the most vulnerable populations. The harm done includes loss of security, abuse of human rights, demoralization of the old, confusion of the young, destruction of environment, and disappearance of knowledge and languages.

For many tribal peoples, everything that is theirs seems to have to be exchanged for things that come from elsewhere – things they may want and need, but things for which they have to pay a dismaying price. Sense and justice urge that all of us look at how to create development that is sustainable and authentic, where the benefits are real and the price is not exorbitant. People need development that is built on recognition of rights, and not on the relentless alienation of rights. The power of this book lies in its plea on behalf of the Himba, on behalf of all such peoples who are attracted to development, and yet threatened by it at the heart of who they have been in the past and need to be in the future. The power of this book comes from the way the authors speak to the past and future of one tribal group by seeing and describing the realities of here and now.

– *London 2002*

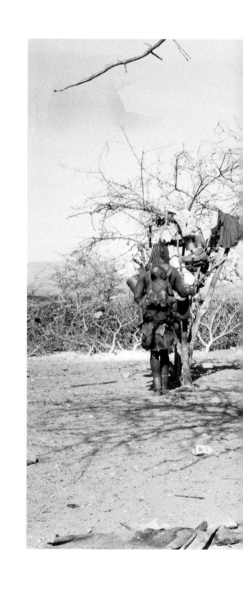

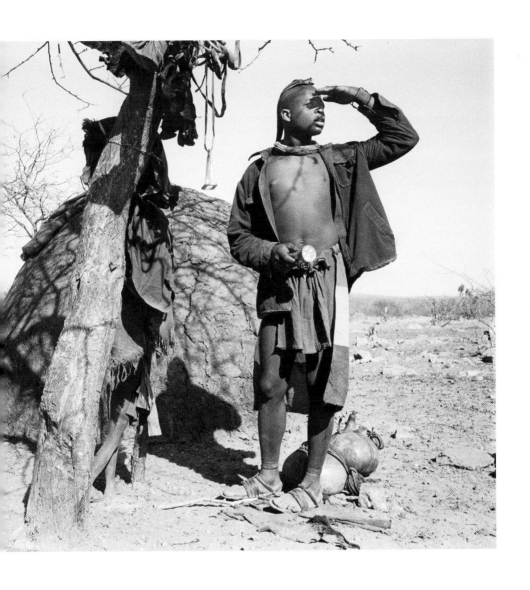

Lines

The healer pulled loops of gut out of the belly of the goat and spread them on the ground. He was looking for a cure for his patient, a man of about forty-five whose three wives, naked except for skirts of animal hide and coils of jewelry, were sitting behind him. Other family members and a few curious neighbors had gathered in a circle, sharing the shade of a large mopane tree.

The women glowed red-brown from the mixture of butterfat and crushed ochre rubbed into their skin. The butterfat protected them from the dry hot climate, the ochre made them gleam the color of the longhorn cattle that are the wealth of their families. This shimmering second skin stained everything they touched; the tree trunks they leaned against, the rocks they sat on, the babies they held, all took on an ochre sheen. As they waited for the healer to make his diagnosis, an airplane passed high overhead, invisible except for the white tail that it stretched across the sky. Nobody else saw it; they were all looking at the healer. My eyes went from the guts spread on the ground to the white line in the sky. It was probably a planeload of tourists on an African holiday. I thought about the people in the sky, the people on the ground, and the distance in between.

The innards of the goat confirmed that the man was cursed and told the healer

what must be done to undo the magic. The goat's body was hung in the tree and we all followed the healer down to the dry stream bed where two goats were tethered in the bushes. It was time for the cure.

In this part of southern Africa, the winter sky can stay cloudless and pale with heat for months on end. The airplane's trail of exhaust hung in the faded blue. Below, in the arid reaches of Namibia, between the Skeleton Coast and the Kalahari Desert, the ten thousand people called the Himba moved their herds of goats and cows along routes worn into the hard earth by generations of bare feet.

The sick man and one of his wives were told to sit down in the deep sand. The healer and another man grabbed one of the goats by its legs and, despite much kicking, turned it upside down. They held the goat by its feet and circled the couple, then lifted the animal and passed it over the man and his wife. They did this several times.

Next, the healer got the man to lie face-down with his hands outstretched in front of him. The men in the group covered him with sand until only his head was sticking out. He was left there for awhile. Eventually, the healer grasped the man's hands, and pulled him slowly forward until his whole body emerged from the sand. Up in the sky, the airplane was long gone and the white line had disappeared.

Arrival

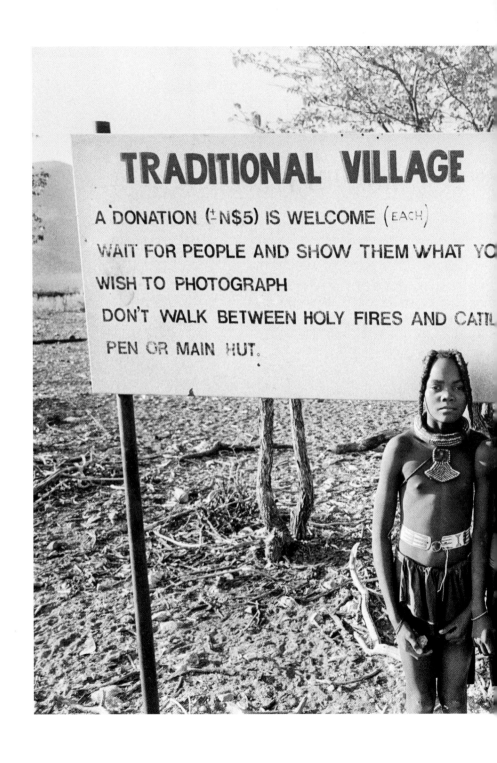

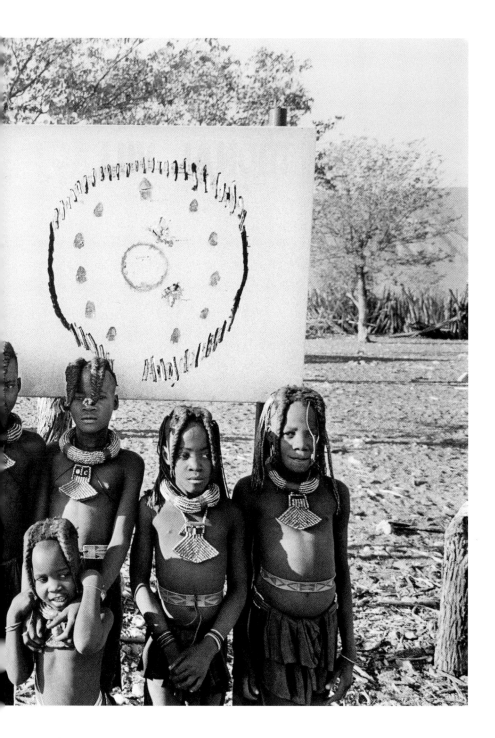

We had come to Namibia to look into the possible effects that a hydro dam would have on the Himba people. We were traveling on a grant from a human rights organization and we intended to produce articles about the situation. According to what we'd read, the Himba were opposed to the dam, saying it would kill them, while the government was determined to capitalize on the hydro power of one of the country's few permanent rivers. We had driven from South Africa and were planning on staying as long as we could. We had been driving north for five days when the fences stopped following us. On the sixth day, the wide gravel road narrowed to a dirt track and after awhile we came to a sign telling us we had arrived at a "Traditional Village," and warning us not to walk between "holy fires" and the cattle pen or the main hut. We parked near a circle of round mud huts and six girls came running. They pointed excitedly and seemed to want everything in sight, the blanket on the seat of our truck, the string of beads around my neck. "Candy," said the girl who looked oldest. "Candy?" I said. "Candy," she replied.

The girls led us over to the huts, bouncing up and down, and speaking in a language that we didn't understand. We responded in English and the whole exchange had a giddy feel. The oldest girl walked beside me, repeating my words in her clear bright voice. The only other people in the village seemed to be an old woman and a teenage girl. The old woman sat alone, hunched over a cooking fire. We tried the greeting we had learned from a travel magazine, saying *moro moro* and getting *moro moro* in return.

We were worried about the holy fire. The sign had been explicit about not crossing the line between it and the main hut. We didn't know where the holy fire was or how to ask about it. We kept looking and stuck close to the girls, hoping that by following them we would avoid giving offense.

The entrance to one of the huts was blocked with branches. The older girl wiggled through and emerged with a big bag of sugar. She handed out lumps to everyone, including me and David. The children chewed through theirs in a matter of minutes while I managed a polite nibble and, when no one was looking, put the lump in my pocket.

Before we left, the older girl brought over a notebook in which visitors had written their names, where they were from, and how much money they left. The village had already had several visitors that day – travelers from Germany, Switzerland, and England had donated a total of $165. When David raised his camera to take a picture, the girls lined up in formation beneath the billboard and put on serious faces. As we were driving away we had to pull aside so two Land Rovers coming towards us could pass on to the village.

CAMPGROUND

We reached Epupa Falls in the middle of the afternoon. The place reminded me of campgrounds back in Alberta where everyone parks side-by-side next to their own picnic table. All the campers seemed to have brought folding tables, chairs, and portable barbecues. Four men in short skirts with their chests bare stood nearby watching us. Under the nearest palm tree, several white men in lawn chairs were drinking beer and were also watching us.

The dog was whining to get out of the truck. When the door opened, he ran to the river and leapt in. The current bore him towards the falls and David had to scramble along the bank in order to grab his collar before the water went over the edge.

A young woman was making her way from campsite to campsite; the men drinking beer waved her away, and she came over to us. Her skin was stained red-brown and glistened in the sun; her skirt was made of goat skin and she wore thick bands of jewelry. She had a baby strapped to her back, and carried a carton of orange juice under her arm. When she stuck a finger in her mouth, I could see that her top two teeth were filed into points. She sucked on her finger and it took us awhile to figure out she was asking for a cigarette. I shook my head. The baby on her back reached out a hand; I took it and smiled, hoping the woman would stick around. I was keen to meet people, but wanted our conversation, even the limited kind we could have without a common language, to be about more than just what I could give them.

Another woman with several kids came along and crowded around, asking for candy. When David raised his camera, everyone lined up in snapshot formation.

He looked frustrated and put the camera down. They asked for candy again, but it seemed wrong to give it to them when I knew they didn't have toothbrushes; I hadn't thought about that when I bought it. I left the candy in the truck and everyone looked disappointed and maybe a bit pissed off. The smile on my face grew stiff and the group moved on.

JACKSON

I don't remember how Jackson approached us, but we were happy to meet an African

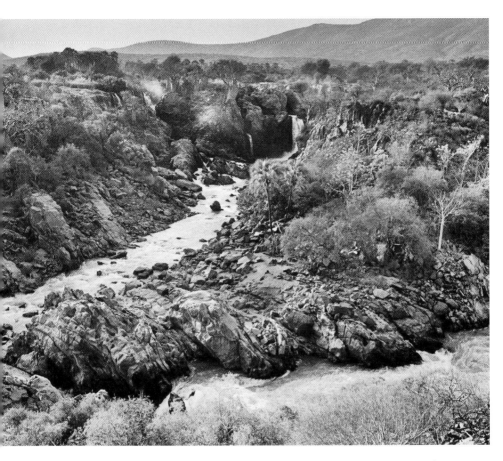

who spoke English. We explained that we were journalists from Canada, here to make a story about the Himba. Jackson had worked with journalists before and mentioned a woman from New York who did TV shows. He explained that because he was from the Herrero tribe, he knew a lot about the Himba. He said that both groups speak the Herrero language, that they had once all been the same people. I remembered this from the reading I had done. The Himba were the part of the Herrero tribe that stayed in the northern reaches of Namibia when the rest moved south. While the Himba continued to live in the isolation of the north, the Herrero came into contact with the German colonists who were creating the country of South West Africa. War between

the two broke out in 1904 and even after the Herrero surrendered, the Germans continued to pursue a policy of extermination that resulted in the death of about eighty percent of the tribe. The Herrero women are unmistakable; many still wear the wide bonnets and pioneer-style dresses of a century ago.

The next time the woman with the baby came past, David got Jackson to ask for permission to photograph her. She told Jackson it would cost the white man four dollars to take her picture. David and I felt uncomfortable with this; journalists weren't supposed to pay for photographs, and at four dollars each we wouldn't be able to afford a lot of pictures. David got Jackson to explain that he wanted to take many photographs and he didn't want the woman to stare into the camera, he wanted her to ignore him and go about her life like she usually did. He offered her ten dollars and a bag of sugar on the understanding that he could take her photograph whenever he saw her. She agreed.

We decided to hire Jackson to help us for a few days. He agreed and went off to collect his things and returned an hour later wearing the same cut-off jeans and T-shirt; he had put on a safari hat, carried a small notebook, and had brought nothing else. A helicopter flew over, following the course of the river, and Jackson told us it belonged to geologists who had been doing tests related to the dam. Some of the Himba men had been working for the geologists, he said.

We walked around the area and came upon a group of men in a large canvas tent. One of them, a tall man in shorts and a Nike windbreaker, told us they were Namibian border guards. They weren't wearing uniforms and appeared to have no weapons. The Kunene River divides Namibia from Angloa, its northern neighbor, and the pale purple hills visible on the far shore were in that war-torn country. The man in the Nike jacket began asking questions about where we were from and why we were here. We told him we were journalists from Canada doing a travel story about Namibia. He nodded knowingly, told us he was an Ovambo, the tribe of Nambia's president, and said he was a doctor who had been trained in Cuba and Russia during the war. He complained about the lack of medical supplies at the border and asked us if we had any malaria pills.

As we spoke, a small plane circled low overhead, and then landed on the dry ground beyond the palm trees. A Toyota Land Cruiser with an open top drove up to

meet it. It turned out that Epupa Falls had two luxury lodges which catered to fly in tourists. One of the lodges was surrounded by marigolds; the other was hidden behind a tall wooden fence that looked like a fortress.

Back at the campground, a group of South Africans were running a generator. I wondered if it was to keep the beer cold. We made a fire, cooked supper, and were eating with Jackson when a small man in pressed trousers arrived. His name was Amos and he explained that it would cost fifteen dollars each to camp for the night. We had just been discussing our budget with Jackson and had figured we could pay him fifty dollars a day for acting as our translator. We had been planning to stay at Epupa Falls for several weeks, and hadn't expected to pay anything for it. We tried to barter our way into a special rate, but Amos said he didn't have the authority to give us a deal. After he left, Jackson told us Amos was a Himba who no longer dressed like a Himba. Jackson also told us not to worry, we would go to a place where no one collects money for camping. When we finished supper, he started to do the dishes, but I felt funny about that and insisted on doing them myself. We lent him a blanket and pillow and he slept beside the fire.

TOURIST

Early the next morning we walked downstream for a view of the wide stretch of cliff and water that is Epupa Falls. The border guard in the Nike windbreaker waylaid us for a few minutes before we started down the trail, asking again if we had any medicine for malaria. He admired my hiking boots and said we should send him a pair when we got back to Canada.

We scrambled down a path to a place along the shore where we could look back at more than a dozen waterfalls dropping from the cliffs. Several baobab trees clung to rocky outcrops between the falls, and David pointed at lovebirds in the bush beside us. We were both upset that the likely fate of all this was to be buried under several hundred feet of water.

We felt that we had been deceived by the newspaper article that had made us decide to come here. It had led us to believe that if the dam were stopped, the Himba would continue

with their traditional ways, but already we sensed that this could never be the case. We hadn't expected so many tourists, and from the way that Jackson seemed to be making his living as a freelance guide, we surmised that plenty of journalists moved through here too. Our own experiences were giving us a feel for the impact travelers were making.

As we sat looking at the falls, we were joined by a German engineer named Klaus, here on vacation with a tour group. When we said we thought it was wrong that this natural beauty should be flooded, Klaus talked about how valuable electricity was to a developing country. One must be realistic about these things, he said. We talked about the impact the dam would have on the people and Klaus agreed it was unfortunate, but claimed that the Himba would have to develop someday and it may as well be now. He said he believed that people are basically lazy and can't resist the appeal of western technology. He said the Himba were always hitchhiking rides, that just like us they would rather drive. Klaus agreed that it seemed crazy to flood this place, but said that was the way the world worked. I looked at the rocks, birds, and trees, and wondered if the world might work differently. Klaus said again that you can't change things, you must be realistic.

FIRE

We left the campground that afternoon and followed a boulder-strewn track up river to a single hut. Jackson introduced us to the young couple staying there, a brawny man and his beautiful wife, then we all sat down and Jackson explained to them what we wanted and found out what they wanted in return. Just when we had reached an agreement, another man arrived with several women and children. Jackson introduced the new man and explained that he was "a big man," in other words a headman, who wanted us to drive him to Epupa Falls. Jackson thought it would be a good idea, so David agreed. The headman and Jackson got in the front, the wives and children in the back. Within minutes, the only person I knew in Namibia and almost everything I owned had disappeared down the road.

I was alone except for the goats grazing the nearby hillside and the boys who were keeping watch on them. By six o'clock the sun was going down and the temperature

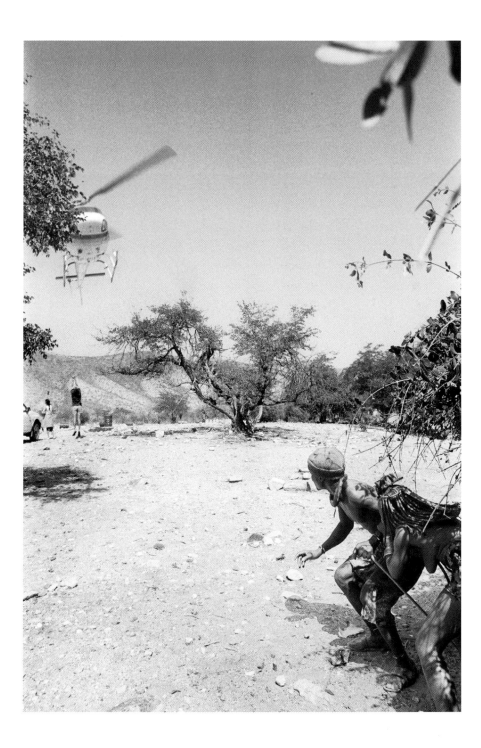

was dropping rapidly. Small bats were beginning to swoop through the air. I had dressed for the hot, thirty-degree day, not the near-freezing night. I warmed up by gathering rocks, setting them in a circle, and collecting wood, but I had no matches. Eager to do the right thing and cement new relationships, David and I had parted without thinking. Now, I felt both foolish and afraid.

Up a shallow ravine, through the herd of goats, smoke swirled over a fire around which the three boys sat, wrapped in blankets. It was my turn to ask a favor. I stalled,

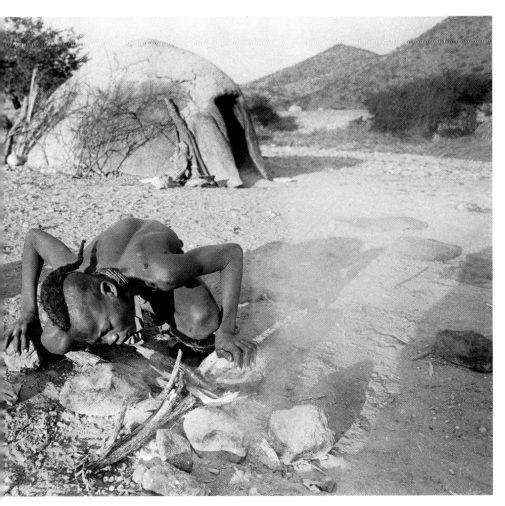

feeling embarrassed. It got colder, the light fell, and one of the bats swooped low over my camp stool. I wondered how I could carry fire, so I picked up the hibachi grill and headed toward the boys.

The boys watched me approach and when I was near gestured for me to join them. A blackened tin can was boiling on the fire while they sat turning the pages of what I recognized to be a house and garden magazine from South Africa, open at a photo of the white-walled interior of a Cape Town condo.

Rather than joining the boys, I pointed to their flame and then over to my cold pile of wood. The oldest boy pulled a smoldering branch from the fire and handed it to me. So that was how you did it. The grill hung heavy from my hand as I walked back across the rocky ground with an ember on the end of the stick. When David and Jackson drove into camp a while later, I was sitting beside a roaring fire.

MARIA

She arrived after supper, pulled up a stone and sat down, settling her young daughter between her knees. "The men have no respect for the old ways," she said through Jackson. "My husband should have stayed to greet you but he has gone drinking at Epupa Falls so I have come instead." She wouldn't give us her Himba name. "I took a new name," she said, "a better name," and insisted we call her Maria.

We had met Maria earlier that afternoon, when Jackson had helped us negotiate with her husband. She had sat silently beside him, staring at us and pulling hard on a pipe. Her husband had rejected our initial offer, saying that the sacks of ground corn we had were only little ones and he had many people to feed. We had been embarrassed and also worried; so far everything had cost more than we expected. We had added a sack of sugar and a pouch of coarse black tobacco, and got his grudging acceptance.

Now it was night and his wife was sitting at our fire, stretching her legs, and reaching out her bare arms to embrace the warmth of the flames. "Why haven't you got a baby?" she asked me, and I struggled to describe how the birth control pill works. It came out sounding more like magic than medicine. "Babies are a problem," she said. "You get them from the man, they hurt and then you must always carry them around." Maria said she had already decided that her daughter would go to school to learn English so that she could go to the tourist camp to get things from the white people.

David asked if Maria remembered the war and she responded with, "Tat-tat-tat-tat-tat." We all laughed and when David made the boom-boom-boom of shelling, she nodded vigorously.

The coiled copper bracelet on her forearm glinted in the fire light. "Do you ever take the bracelet off?" I said. "No," she said, "it is for hitting my husband if he tries to hurt

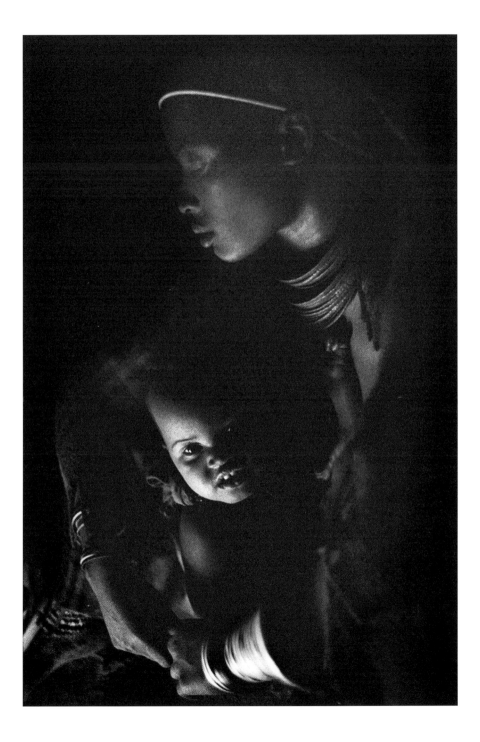

me." She laughed and demonstrated with a swift thrusting motion of her forearm.

She asked where our plane was and I explained that the plane that brought us to Africa did not belong to us, that it was like the train, something you bought a ticket for and rode in with many other people. She knew about the train, she said; she had taken it to Windhoek, the capital, last year. We had passed through Windhoek ourselves only a week earlier, the sidewalks had been crowded with businessmen and tourists, the stores full of safari gear, and people were talking on cell phones and sipping espresso. Maria had gone with friends and said that it had been good to see the city, but not to stay there. The traffic lights had confused her and she had had to stand on the street corner for a long time, not knowing when to cross.

I asked her how old she was, but she didn't know and said we should ask her husband. He had not yet returned when Maria bid us good night and went back to the little hut. During the night we heard people passing, and early next morning one of the boys was herding half a dozen goats down the path towards Epupa Falls. Jackson said the animals were being sent to pay for what Maria's husband and his friends had drunk the night before.

SHAVING

It was mid-morning when Maria's husband emerged from the hut, blinking at the light. Jackson was away from camp so conversation was limited, but throughout southern Africa the word for hangover is *babalaas*. When David said, "Babalaas?" Maria's husband broke into a grin.

Maria's husband used our soap and basin to wash up and then he mimicked shaving his face, and nodded emphatically when David pulled out his razor. He sat on our stool and David poised the razor over his upper lip, hesitating a moment to make sure they understood one another. As the photographer labored in the role of barber, I pulled out the small camera I carried for snapshots and took a picture. David shaved off the man's mustache and trimmed his beard. Maria's husband looked into our mirror from various angles, smiled broadly, bid us goodbye and headed down the path towards Epupa Falls.

As soon as he was gone, Maria came over with her daughter, pointed at the razor

and then at the girl's head, where the temples had been shaved but now stubble had grown in. David put a new blade in his razor. Like Maria, the little girl's skin was coated with butterfat and after only a few strokes, the blades of the Twin Trac were clogged. The shaving took half an hour with many breaks to clean out the razor. Jackson returned mid-shave and laughed at what David was doing. He joked with Maria in Herrero, and they both laughed about something that Jackson didn't translate. When Maria left, she told Jackson we should go to Epupa Falls, everyone was there. Then she too headed off through the palm trees.

DRINKING

We were camped on the path to Epupa Falls. It was customary to say hello to everyone who came within earshot, so within a day or two, the basic greetings of *perivi?* (how are you?) and *peri nawa* (just fine), were rolling off our tongues. Some of the people who passed through stopped for a short visit, while others lingered by our fire for hours, drinking tea and sometimes staying to share supper.

Jackson reported that a Herrero trader had arrived at Epupa and was selling something that made people talk too much; he laughed when he said it. He also said the Himba didn't know any better so they sold their goats too cheap just to get drunk. The trader paid $40 for goats that he could sell in town for $100.

Many of the people using the trail to Epupa Falls were going to the party around the trader's truck and one afternoon we decided to join them. The sun was beating down on the scene. The trader was standing in the bed of an old Ford truck, looming over his customers who waited with bottles which he refilled from one of several open barrels. A group of young men were dancing. Jackson had told me some of them were working for the geologists, and that the trader was here because they had just been paid.

Maria was there, holding a half-jack of green mint punch which she pressed into my hand. I raised the bottle and took a sip, putting a thick sweet seal on our friendship. I remembered someone telling me that the Himba liked hard sweet alcohol, and that in areas not accessible by road, some traders walked in with bottles of mint punch, traded them for goats, and herded their profits back to town.

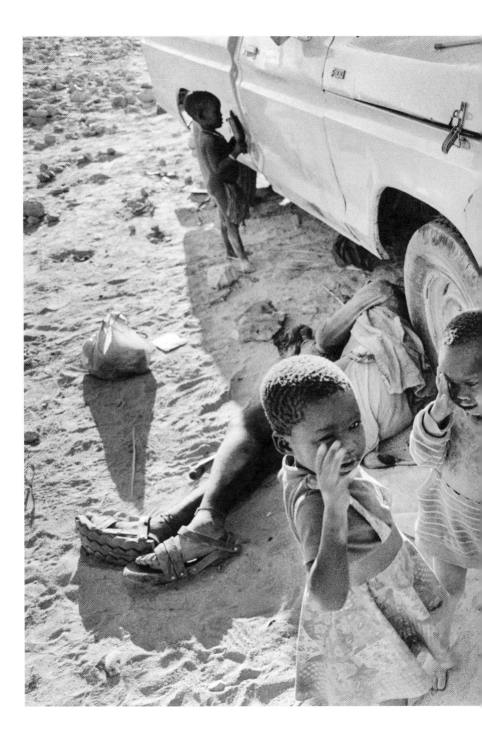

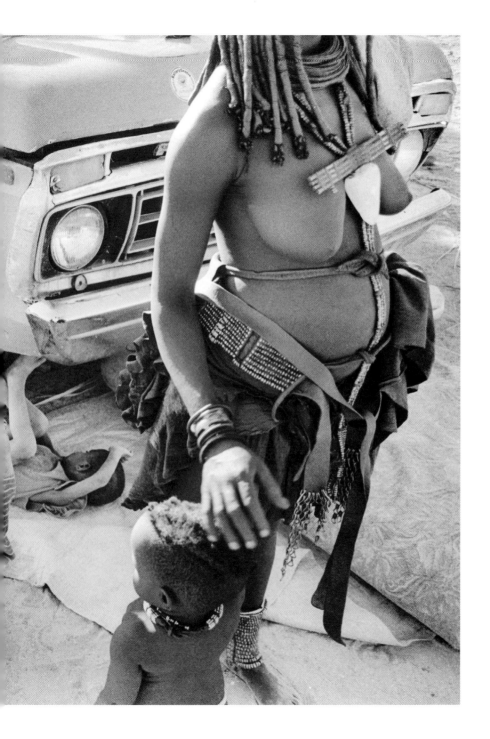

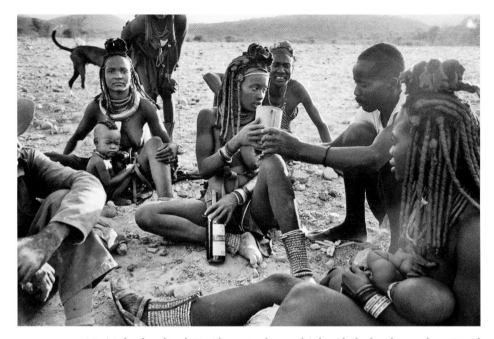

Maria's husband took David over to share a drink with the headman whom David had driven to Epupa Falls. Another man shouted, "Hello Mrs David!" and I turned to find the border guard in the Nike windbreaker waving at me. One of his friends went over to the truck for a refill from the barrel that held a distilled drink called *okandjembo*. The bottle was passed from hand to hand in a genial fashion, and when it came round to me, I took a sip too. The clear liquid burned going down and tasted like vodka gone very wrong.

The border guard had been drinking for awhile; he kept calling me Mrs David and flirting in an outrageous manner that sometimes strayed towards threatening. I looked around for my husband and saw him dancing with the young men. The border guard leaned towards me. Why, he wanted to know, were we staying with these Himbas? They are stupid, he said. They don't know how to live properly. He and the other border guards were trying to help them and get medicines for them when they could. They were also watching the Himba, spying on them, and he alluded to all manner of things crossing the porous border of the Kunene River. He wove politics,

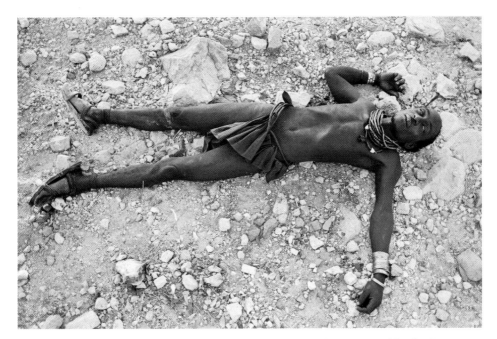

guns, and diamonds from Angola into our conversation, which was twisted by drink and regularly interrupted by Maria, other border guards, and whooping men.

It didn't take long for one bottle to be emptied, another bought, and I felt like it was probably my turn to buy the next round. Sharing alcohol was something I had thought I would never do here. It was unnerving how what had seemed so straightforward back in Canada was turned inside out on this sun-baked earth. The age-old rite of cementing friendship with drink crosses many cultures, and not taking my turn in buying a round would be both rude and patronizing. The next time the bottle was empty, I gave the border guard ten dollars and he went for a refill.

I was relieved when David got back to me. He was excited because the headman had said that if we wanted to learn about the Himba, we should come stay in his village. It was located along the river and would be greatly affected by the dam. They had decided we would go to the village the next morning. Now, however, night was starting to fall, and the headman was passed out stone cold on the ground. We walked back to our campsite in the dark, stumbling over the rocks.

KARAMATA

The headman's name was Karamata and his village lay an hour's walk upstream from Epupa Falls. A road ran between the village and the river, a bumpy route popular with the 4x4 crowd, and it was beside the road, under cover of several large trees, that we parked the truck and made camp.

The first few times I walked into the semi-circle of huts that made up Karamata's village, I hesitated, unsure about how to respect the holy fire and not cross between

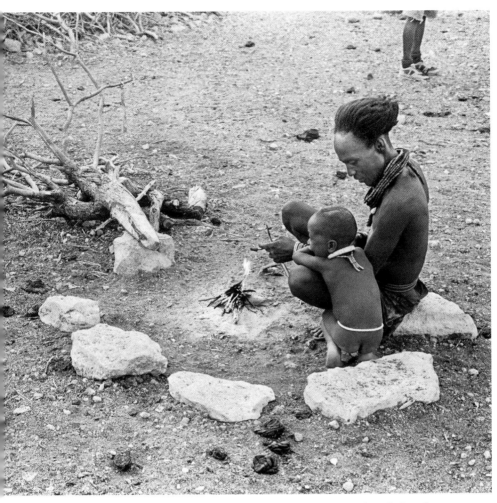

it and the main hut or the cattle pen. The cattle pen was easy to identify, but there was nothing obvious by which to distinguish the main hut from the other three, and nothing I could see to indicate which of the two fires was holy. The fires were small, barely smoking affairs, not big roaring fires like the kind David and I and the rest of the white people had made at Epupa Falls. I thought maybe by following Jackson I would be okay. The holy fire was something the Herrero shared with the Himba, but Jackson didn't seem to have qualms about walking anywhere, and after wandering around

behind him for awhile, I began to feel uncomfortably like I was crossing the line over and over again.

After a day or two, the rocks and huts began to look familiar and the two fires became easy to distinguish. The cooking fire often had an old tin can boiling away on it. The holy fire was never used for cooking, and the rocks around it were well back from the wood, far enough away that a person could sit on them. The holy fire was a short distance in front of the first wife's hut and early in the morning Karamata could usually be found here, with one of his children sitting close beside him. The holy fire was the conduit of ancestral voices. Only people who had been introduced to the ancestors were allowed to cross the line. Karamata explained that the fire had been passed down to him from his father. Though his father was dead, he could speak with him when he sat at the fire; he laid out his problems and his father gave him advice about what to do. To my untutored eyes, it often looked like the holy fire had gone out, but wood in the Kaokoveld was dry as a bone, and held heat for hours. Karamata would squat down and, with his face next to the earth, blow in the coals and the holy fire would spring up again, smoking orange.

WIVES

Karamata's youngest wife was named Montebella and she liked to party. We had met her when we were still camped back at Maria's hut. We had been sitting around the fire, almost ready for bed, when Maria came down the trail with her two-year-old daughter on her back and a baby strapped to her stomach. She dropped down on a stone near the fire and sighed. The baby's mother, she said, was too drunk and kept falling down on the path. A few minutes later, we heard laughter and then Montebella stumbled into camp, her knees scraped and bleeding, her mood boisterous.

Montebella was pretty in a hard, challenging way. The set of her face, the attitude with which she pulled on a cigarette, seemed to belong in a smoky nightclub. She was skilled at getting white men to give her cigarettes and fearless in approaching them. She was part of the crowd of younger Himba who spent most afternoons at Epupa Falls where there was usually a bottle being passed around.

Montebella had been at the big party when Karamata had invited us to come stay at his village. The next morning, when we were preparing to move to his village, Montebella had came over to ask for a ride. It was then that we learned she was his wife. When we arrived at the village, she headed for the nearest tree, lay down in the shade with her baby on a cloth beside her, and went to sleep.

The second wife had welcomed us. She was rocking a gourd back and forth with one arm, and holding a baby girl with the other. Her long legs were stretched out, her ankles adorned with the thick cuff of iron beads women receive at puberty and wear ever after. When she smiled, her eyes were warm, without the scorn Montebella's eyes could hold. She patted the ochre-stained rock beside her and invited me to sit down. The butterfat on her body was rancid in the hot sun. Flies swarmed, landing on her and me and the baby.

I reached out my arms, asking if I could hold the baby. There were two babies at the village, Montebella's little boy and this little girl. Over the week we spent with Karamata and his family, the babies were always nearby and seemed to spend much of their time being held, if not by their mother, then by the headman or one of the other children. The little girl relaxed against me, staining my shirt with ochre. She seemed healthy, her limbs were strong, her mood content. When I kissed her head, her mother smiled approval.

The first wife was the oldest and I hadn't spent much time with her until one afternoon when she sought me out and invited me to come and learn from her about "women's things." I asked Jackson to join us and we left the bright heat of the afternoon to crawl into the cool dim interior of her hut. We sat on the floor of hard packed earth, around a tiny slightly smoking fire. Jewelry hung off bits of branches sticking out from the wall like hooks. A blanket lay in a heap near the wall next to a shallow cardboard box containing a package of sugar and a box of tea.

The headman's first wife held out a container made from a piece of cow's horn and put it up to my nose. It was filled with a paste that smelled faintly fragrant, organic but not unpleasant. She pantomimed rubbing it under her arms and under her skirt. Then she picked up another container, this one holding what seemed to be a blend of grasses. She took a pinch, blew on the fire to bring a few sparks to life, then sprinkled the grasses on the fire. It worked like incense; the scent wafted up with the smoke, but

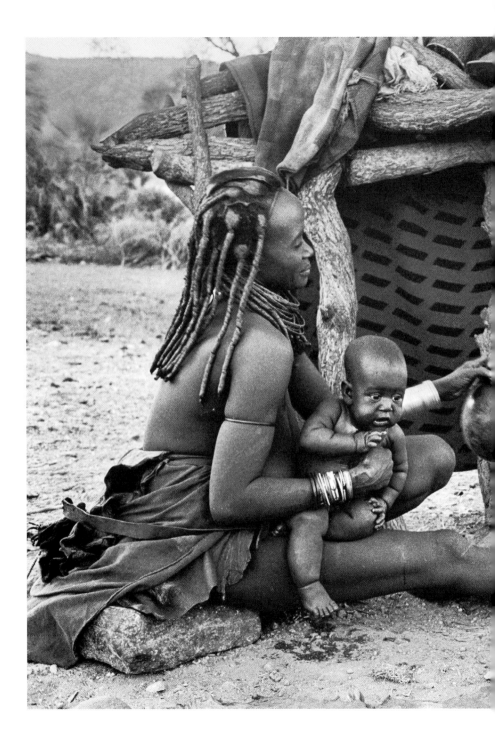

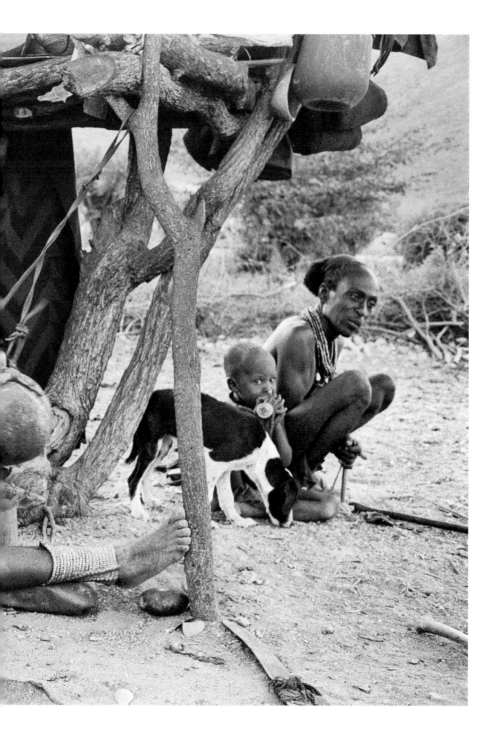

before it filled the room, she moved into a squatting position over the tiny fire, pulled a blanket around her waist, and used it to trap the smoke between her legs. Jackson looked uncomfortable. "They do this for the men," he translated.

I told Jackson to ask the headman's wife if there were any questions she wanted to ask me. She spoke with a gleam in her eye, and then Jackson translated. He said that when the wife sleeps with her husband, she takes off her clothes, and the woman wanted to know if I wore my clothes when I slept with my husband.

I laughed. Jackson was embarrassed and wouldn't meet my eyes. I shook my head and mimicked undressing. She laughed, looking delighted.

She spoke again and Jackson told me she wanted to know whether my husband and I "did our business," as he put it, in the day or in the night.

"Both," I told Jackson, wondering what words she had really used for sex.

Next she asked Jackson what I did if my husband wanted to do business and I didn't want to.

"I say no," I told her. Jackson translated, then said she wanted to know what happened when I said no. I laughed. "Then we fight," I said.

She responded by saying that if the woman said no, the man would hit her. Even if the woman was feeling bad, Jackson translated, it was her job to sleep with her husband. She may say that she isn't feeling well, but she must still tell her husband to go ahead and do his business.

I got Jackson to ask her if the wives fight, and he told me she said they all got along.

The dangerous gleam came back into her eye and Jackson's voice was barely audible when he translated her next question. She wanted to know whether my husband and I did our business front or back. While asking the question she knelt on her hands and knees, doggy style, looking at me over her shoulder. I didn't need Jackson's muted translation to start nodding, and she and I burst into laughter.

Jackson looked like he was ready to crawl out of the hut when I asked if she liked it when she and her husband did their business. Her voice was quiet when she answered and Jackson relayed the words as, "Ah, it is just what a woman must do. There is a husband and there is a wife and they sleep together."

44

I said that in my country there were some women who chose to sleep only with other women. They did not sleep with men. When Jackson had translated my words, she nodded and said that, yes, they knew about that too, but the men didn't like it, so they had the women sleep in different huts.

Jackson's eyes had been fixed on the floor for most of the conversation. He had been inching closer to the door and now he looked like he was about to leave. I thanked the first wife and followed my translator back into the sunshine.

The next morning we learned that the first and second wives had received word that a relative had died in a distant village. They were smiling as they made their preparations to go to the funeral where, they told me, they would sit and cry for many days, maybe a week. The sun had climbed well into the sky by the time the two women walked out of the village and started down the road. Each of them carried a cloth bundle on her head, and the second wife had her baby on her back. Several of the children started with them down the road, as did David, hurrying ahead to photograph the travelers before everyone said a final goodbye and the women continued on down the rutted track by themselves.

GOATS

The goats cried like babies. They raised their noisy voices first thing in the morning and cried throughout the day. Now it was night and they were quiet. "How many goats do you have?" I asked Karamata. He had taken to joining us around the fire in the evening to share our supper. These evening conversations were calm and friendly, and even Jackson seemed to relax and enjoy them. Karamata looked at me and said, "There are too many goats to count."

The Himba way of knowing the world had not, until recently, involved putting numbers to things. Like Maria, Karamata didn't know how old he was. "We don't count years," he said. He was unfamiliar with numbers, although, as we would find out, he did understand that there is a meaningful difference between $20 and $200. Throughout the region, we would meet people who were learning to count under the tutelage of money, looking long and hard at the coins in their hands, trying to

understand how much purchasing power they held, what they could trade them for at the store, whether it was sufficient to procure a bag of candy, a bottle of wine, or a fifty-kilogram sack of ground corn.

When it came to his herd, Karamata didn't need numbers. Ever since he was a child he had spent his days tending goats and cattle, and he could tell if an animal was missing simply because he knew each one of them. In their turn, his children were already involved in caring for the herd. Each morning they trailed behind their father as he made his way through the animal enclosure, sorting the babies from their mothers and preparing to send the herd out for the day. When I did a count I tallied over a hundred goats and about fifty longhorn cows. Despite the dry land in which they live, the Himba are among the wealthiest herders in Africa. The herd was Karamata's living bank account, requiring daily walking, feeding, and watering. Herding was one part physical labor to three parts killing time, and was an activity well-suited for the children. Even the little three-year-old was comfortable around the animals, picking up baby goats and carrying them around like children back home hefting kittens. The previous afternoon, the girl who was six or seven had dashed in front of a group of about twenty-five stray cows, shouted, thrown a few stones, and redirected the big beasts.

At night around our fire, the subject of medicine came up frequently and barely an evening passed when Karamata didn't ask us for pills, usually for the pain he got in his stomach, sometimes for malaria. One night Karamata asked if we had any medicine for jackals. He was worried about jackals getting the baby goats and said he was going to have to make a big fire to keep them away. He said there were no lions anymore, so he didn't have to worry about them, but his goats were still vulnerable to attack from crocodiles, who ate them when they were drinking at the river, from leopards, and worst of all, from jackals.

"Your gun," David said, "is medicine for jackals." We knew about the gun because earlier that day, the young white man who ran one of the lodges at Epupa Falls had ridden over on his ATV to visit and Karamata had brought a rifle out of his hut to ask for help in fixing it. The gun had been given to Karamata by the South African army during the war. The young man from the lodge was a regular visitor at Karamata's village; he knew all about guns, and after checking it over, determined it was in need of

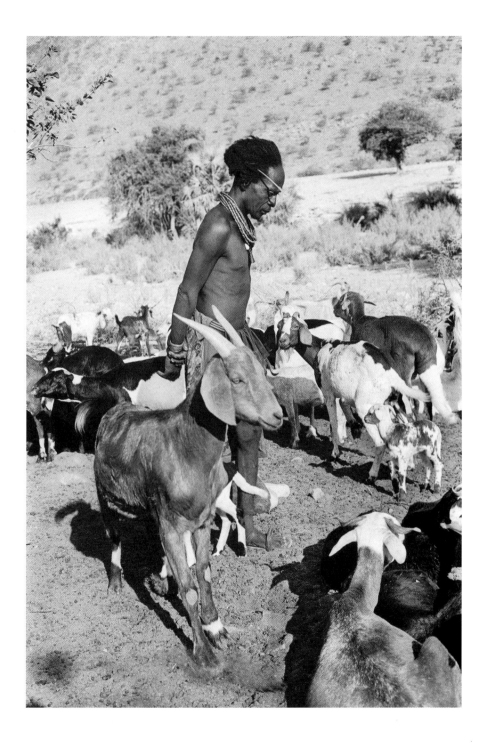

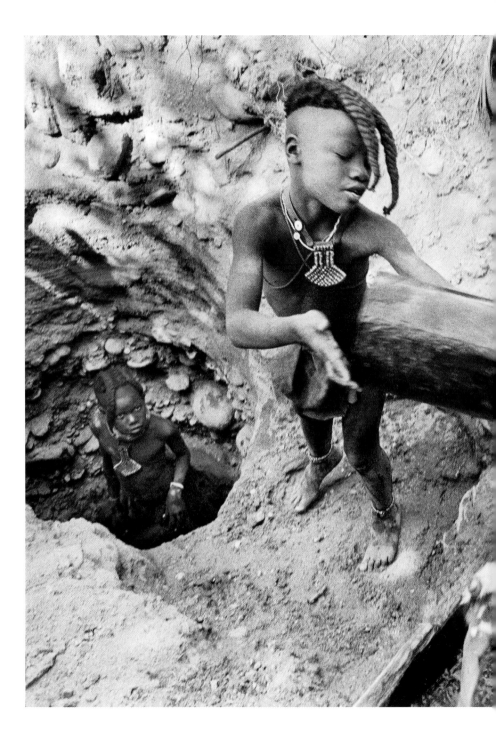

cleaning, and took it away, promising to bring it back soon.

I added another stick to the fire and asked Karamata how many children he had. He didn't know, but said he had other, older children, some of whom were across the river in Angola. With that he rose to leave, explaining that because his first wife was away, he was sleeping with their child and he didn't want wake the little one by returning to the hut too late.

SQUATTING

Like Karamata's family, we were spending most of our time outside, heated by the sun, blown by the wind, surrounded by flies. The weather touched our skin from the moment we crawled out of our truck in the morning until we crawled back into it at night. At first I felt battered by it. I was used to living indoors where I could watch the weather and the bugs without feeling them on my face.

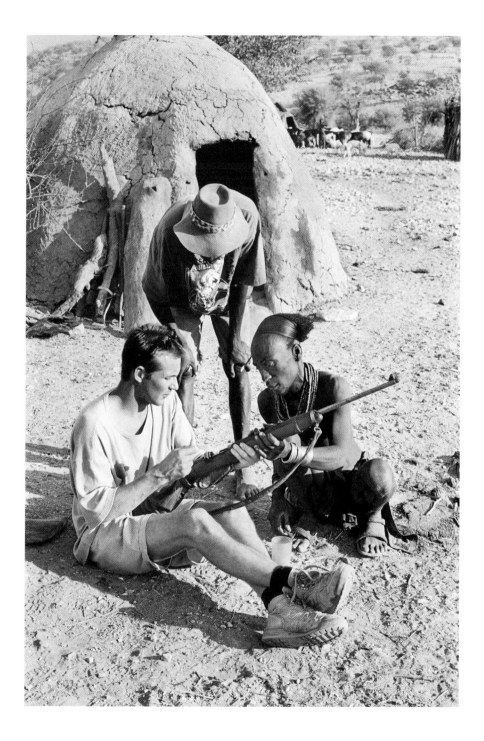

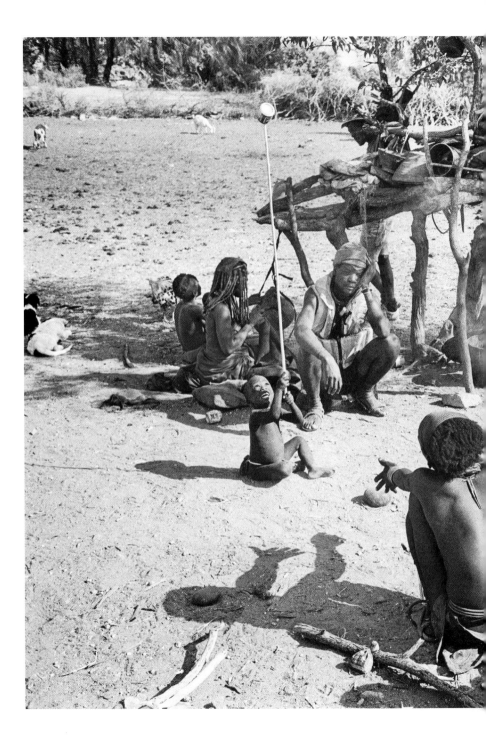

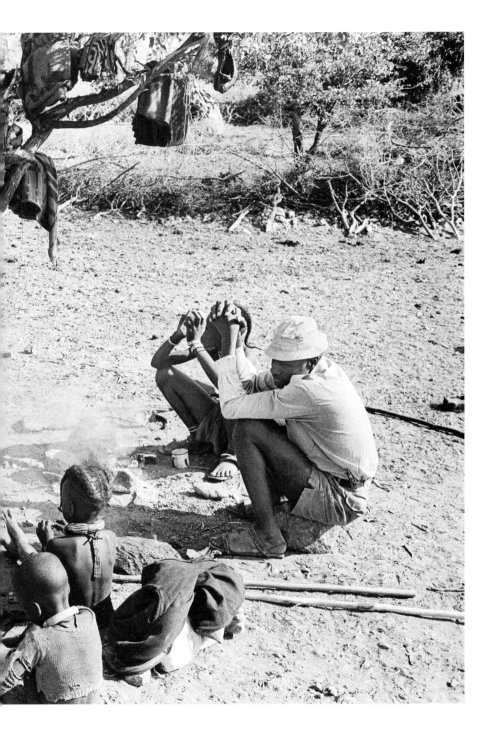

Much time was spent hanging around the fire with the family. They could sit on their heels, talking and looking totally relaxed for hours. I tried to copy them, but when I dropped down on my heels, my thighs began to burn and in less than a minute I would have to shift my weight from one foot to the other, and didn't manage more than two or three minutes before having to pull out of the squat. We had brought two camp stools with us and when one of them broke, David and I started taking turns sitting on rocks, squatting to eat, putting our asses on the earth.

I didn't mind losing the camp stool. Our belongings felt so much more visible around the Himba. Every time I opened the back of the truck, their curious eyes roamed over everything. Under their scrutiny, I began to feel the weight of my possessions. Some days it felt like they wanted everything we owned. Karamata's family used us like a store, coming in the morning to get sugar and tea, asking regularly for sacks of ground corn. Once the goods were gone, the paper packaging hit the ground. Remnants of what white people had given Karamata's family littered the village. They were accustomed to organic garbage, stuff that melted back into the landscape. The refuse near the fire spoke of the way economic norms were blending; the hoof of a goat beside a faded pop can, candy wrappers next to several cow bones.

TOURISTS

At least once a day, a couple of Land Rovers would appear, jerry cans and spare tires strapped to their roofs. The children always heard them coming long before I did. They would race to the road and wave like mad. Sometimes the vehicles stopped, the cameras came out, the kids formed up into a line and stood still, staring into lenses. Then the candies were handed over, doors slammed, engines accelerated, and the kids' voices would clamor for more as the vehicles drove away.

One afternoon, two guides brought their clients to the village: an Italian couple with large camera bags who spent a lot of time consulting about their equipment, and a retired American in a wide straw hat who kept his arms folded across his chest and talked mostly to his guide. There we all were: two guides, the American, the Italians, David and me, all watching the Himba. A chicken strutted past the fire, followed by a skinny white dog.

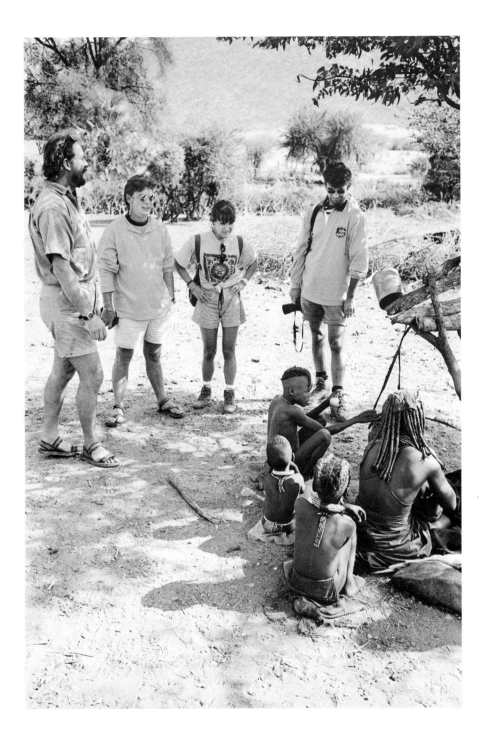

Two of the kids scraped cornmeal porridge out of a bucket, using their hands like scoops. Montebella was sitting in the shade rocking a gourd back and forth, not looking at anyone.

David motioned for me to move aside so he could take pictures of the tourists taking pictures of the Himba. I talked with one of the guides, a South African who had served in Namibia during the war. He worked as a private guide for wealthy foreigners on the game park circuit. His American client joined us and they talked about their itinerary; the next stop was drinks at sunset on the cliff overlooking the falls.

Karamata's kids finished eating and started wrestling with one another. The smallest one raced up to where we were standing and the guide crouched down to play with him in what was the first direct interaction between the newcomers and Karamata's family. Everyone's attention shifted to the burly man and the little boy. The child backed off a few paces, then ran up to the guide again. The boy was of that age, barely two years old, when children can feel that they are the center of attention and love to play to an audience. He ran away and came back waving a piece of clear plastic sheeting. The guide picked the child up and placed him in the middle of the piece of plastic, then pulled the sides of the plastic up to just above the boy's waist. The child squealed in delight as the guide lifted him up as if he were groceries in a bag. The tourists watched, Karamata watched, even Montebella watched.

CARS

When tourists stopped at the village, I thought about how white people must appear to the Himba. It looks like all we do is drive around in vehicles stocked with food, take photos, and sit beside roaring fires. They don't see us working, and have no way of knowing that our lives are not an endless round of sight-seeing.

In the evenings, we tried to explain some of the complexities of our world to Karamata. One night we asked Karamata if he thought all white men have cars and he said yes. David then explained that the truck we were driving was not ours, that it belonged to his father and soon we would have to give it back. He explained that in Canada we didn't own a car, that we often walked. It took awhile to make it clear that David was a white man who did not own a car. Once he understood, Karamata burst into laughter.

Change

One day a relative of Karamata's came by. Like David, he spoke some Afrikaans, so the two were able to talk. "Change is come," the man said. "It is time to change." He was wearing shorts and a windbreaker. "Some other of my brothers have put on pants," he said, "and I followed them." He explained that his wife didn't wear traditional clothes anymore either.

The man asked the family why David wasn't paying for the photos he kept taking. Montebella answered that we were giving them ground corn, tea, and salt. Before he left, the man asked David to give him some soap, sugar, a blanket, and a water container. "But if you are not going to live like a Himba anymore," David said to him, "you must get these things for yourself." "Yes, I know," the man replied, "but it is not easy."

The next morning I joined Karamata at the fire where he was boiling coffee in an old army helmet. He asked for sugar and told me he wanted a truck. When I asked why, he explained that if the children got sick, he would need a truck to get them to the hospital.

Before we came here, I had expected to find that the Himba's traditional ways were intact and threatened only by the prospect of the Epupa dam. What we were finding instead was that, while many of the people still lived as herders, based within family units and moving with the seasons, western norms and goods had already made great inroads. The sources of change seemed to be as simple as desire and as complicated as global economics; I felt uncomfortably that David and I embodied both.

Exchange

We had been at Karamata's village for the better part of a week when we decided it was time to go. Over the last few days, Jackson had been less willing to join us when we visited with the family, less willing to translate conversations. And, when he did translate, sometimes he appeared not to be listening, and then, after someone had spoken for quite awhile, he would sum up their words in just a sentence or two. I wondered what we sounded like coming out of his mouth and feared that the words

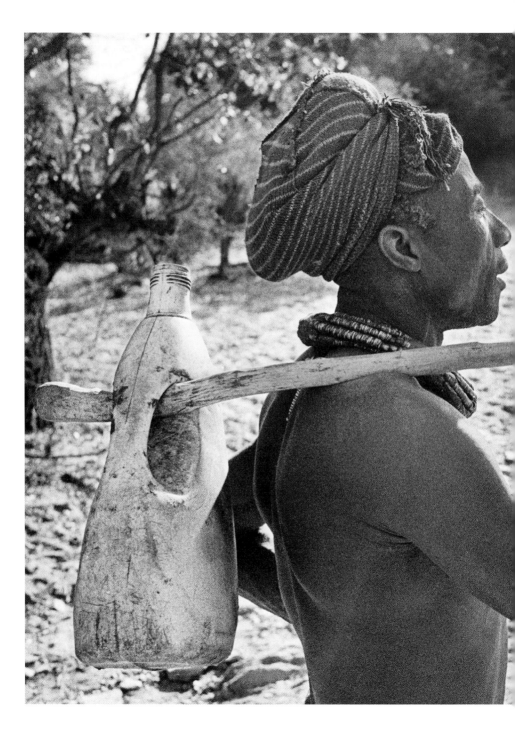

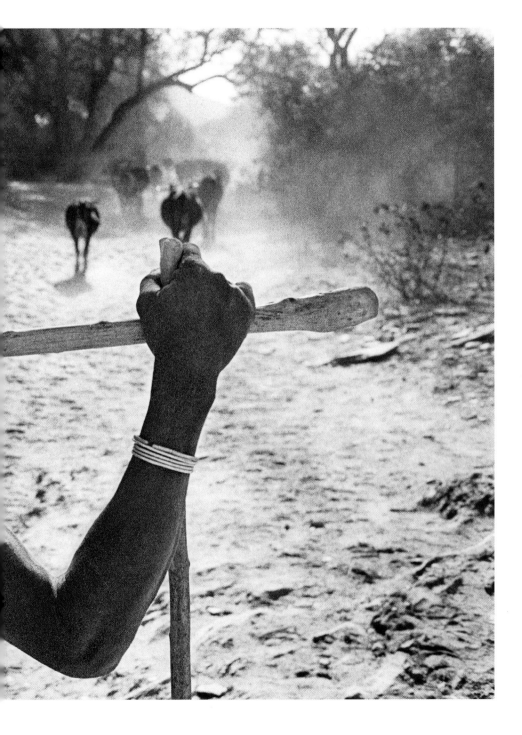

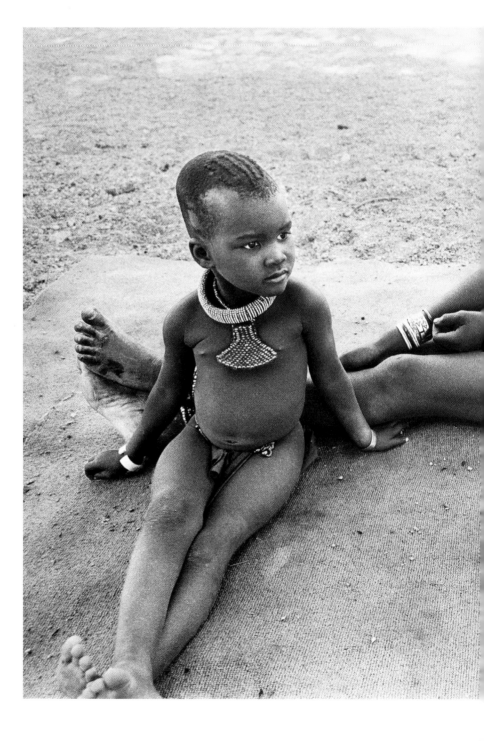

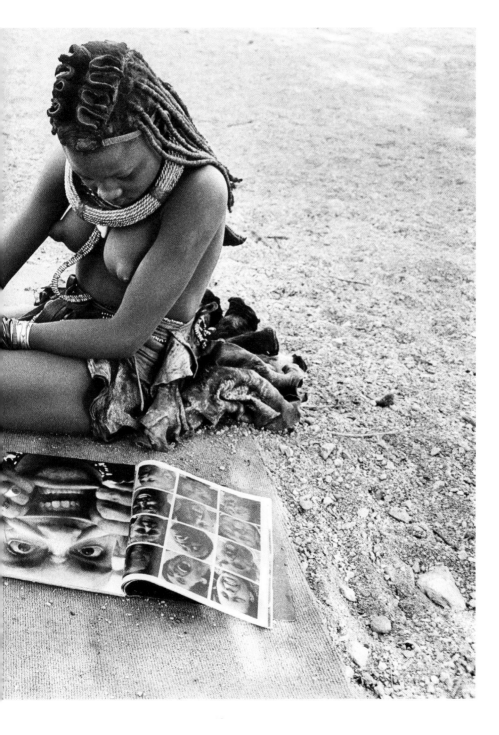

we said were sometimes quite different from the ones Karamata heard. When we told Jackson we would be leaving, he said he was glad, he was tired of spending so much time with people the Herrero consider poor cousins. "Himba means beggar," he said. "They ask for things even when they have them. They have tobacco, they have cornmeal, and still they ask for it." He didn't understand why we were interested in them. "They are so dirty," he said, expressing the disdain that some of his countrymen shared, for Namibia was struggling to join the modern world and for some people the Himba could be an embarrassing reminder of a collective and not-so-distant past.

I sensed that Jackson was also keen to get back to the main road and find new clients. He had figured out that David and I weren't big time journalists. Our food was a giveaway. Lunch was tinned beans, and supper was almost always ground corn and gravy; there were no Cokes or cookies. When we first met, we had agreed to pay Jackson a daily rate of fifty dollars, but in the past few days he had dropped broad hints about how people he had worked for in the past, TV people, had given him a big tip after spending only a day or two with the Himba.

On our last night, Karamata got Jackson to tell us that there had been other people who had camped at his village and taken pictures; they had been from America, had a TV camera, and had paid $200 for each day they stayed and took pictures. We had been at the village for almost a week and the idea that now Karamata expected us to pay $200 a day was alarming. David tried to explain we didn't have much money, and that we had thought the food we had given the family was in exchange for taking photographs.

We would later learn that several international film crews had come through the region two years earlier. Men had been asked to take off their T-shirts and digital watches, while women had been paid to get rid of the candy wrappers, pop cans, and liquor bottles lying around. Photographs had become a means by which the Himba were leveraging themselves into the cash economy. Karamata was merely trying to maximize his return.

He asked for a present instead of money, and requested "a bag big enough for a chief." We offered him the one that held our clothes, complete with double zippers and adjustable shoulder strap, but he wanted the cheap plastic one that held our toiletries. Karamata was grinning when we handed it over. He stood up and walked around the fire, swinging the

bag. He couldn't stop smiling. "I'm like a baboon, so proud of what I've got," he said.

We left in the morning. Karamata was walking the goats out of the village when we went to say a final goodbye. He thanked us again for the bag, and we thanked him for letting us stay with him and take pictures. Then we got into the truck and drove away.

Cameras

Back at Epupa Falls, a man was lugging a tripod towards a group of white people with cameras who were watching a church service taking place under the tree near where the liquor truck had been parked a week before. Many of the bar patrons were there, the men sitting in the shade, the women singing and clapping in response to the directions of black men in pressed trousers and white shirts, one of whom I recognized as Amos, the caretaker of the campground.

The children milled about while their parents listened to Amos preach. Later, I would learn what the gist of his sermon had been: wash yourself, get dressed, and come to Jesus. We had parked nearby so that David could photograph both the tourists and the church service. I was rummaging in the back of the truck when a hand touched my thigh. A little face looked up at me, eyes wide. She was about three years old, dressed in a loincloth with a thick coil of beads around her neck. Two middle-aged white women with cameras were following her. I nodded at them, they nodded back, then spoke to one another in what sounded like German.

The little girl let go of my leg and headed back towards the church service where the preachers were now laying their hands on the foreheads and backs of those gathered and calling on Jesus with loud voices. The two women hurried after the child.

Question

We found a spot along the river where the sand was thick, and the palm trees provided shade during the afternoon. We began to make do without Jackson and found that, despite our limited vocabularies, we could patch together communication out of a few Herrero words, lots of gestures, and funny faces. David's knowledge of Afrikaans

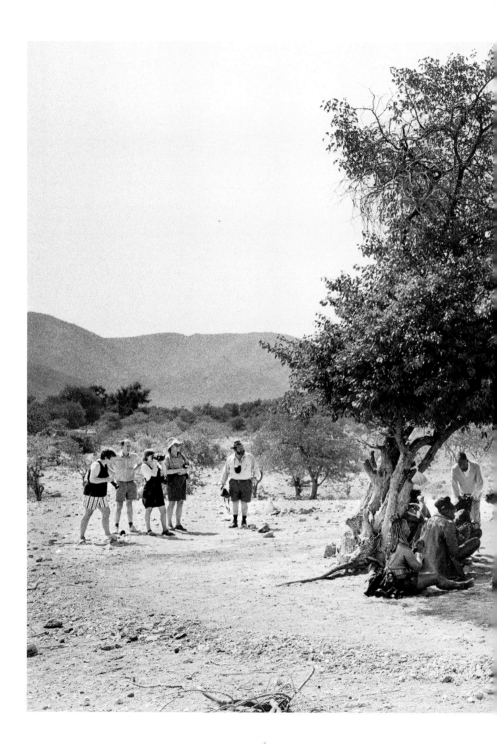

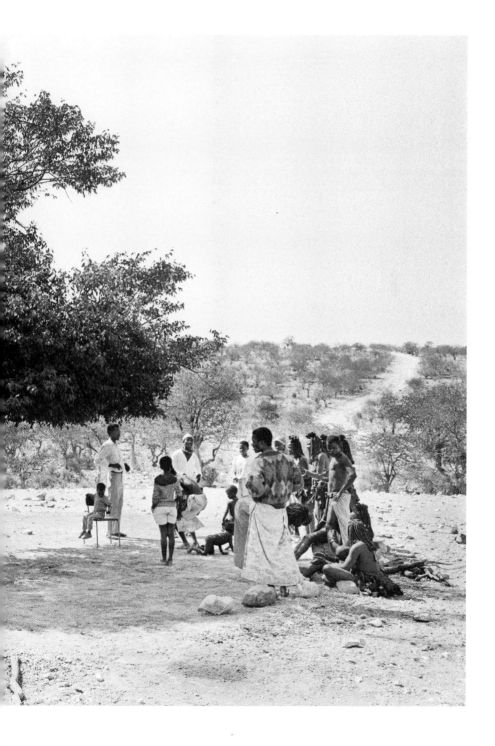

was useful as well, as there was often someone around who spoke enough to help us through more difficult conversations.

There was nothing difficult about the conversation I was having most often. Again and again people asked me, Are you a woman? Are you a man? I learned to recognize the words: *omukazendu* for woman, and *omurumendu* for man. I would say *omukazendu*, then when they repeated the word, usually still with a questioning tone, I would nod vigorously. People often continued to look like they weren't sure I was telling the truth, so I would cup my hands under my breasts, making the small mounds visible through my shirt, and bounce them for emphasis. Some of the women and children would ask the question every time they saw me, then laugh like crazy when I jiggled my breasts.

One afternoon, Maria came by with her daughter. She checked her hair in our hand mirror, and got me to help her tidy it up, showing me how to fluff out the end of the braids. Another trader had arrived with a truckload of alcohol and Maria was off to the bar. I tried to explain that drinking wasn't good for her unborn baby, but she disagreed with me. Smoking that stuff the men sometimes get from Angola was bad,

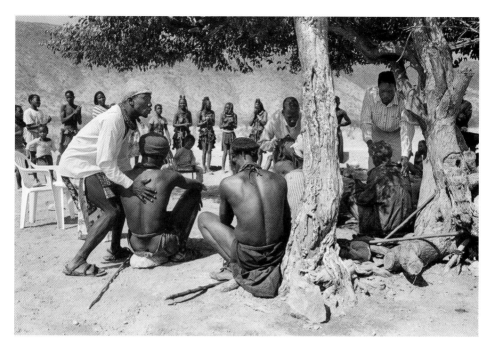

she said, meaning marijuana, but mint punch was fine. She checked her hair in the mirror one more time and headed down the road to the party.

FOREIGNERS

We met a friendly young South African who was scouting the area in preparation for starting a tour guiding business. His name was Jako, he was Afrikaans, and he had been stationed here as a medic with the South African army during the war. He told stories of SWAPO trackers who could follow a trail down on their hands and feet as fast as a South African soldier could run.

"There were no bonfires on this bank ten years ago," he said beside our fire that night. "Light a cigarette here and it could be your last." Now he was back with the long hair of a hippie, carrying basil and oregano he had grown in his garden. "You must live by the moon," he said. He also said that the soldiers, bored during a long, hot, and often slow war, would sometimes throw grenades into the river to blow up hippos and crocodiles.

Another afternoon two professors from the University of Nevada came along in an old Land Cruiser. They were biologists counting the animal population in the Kaokoveld. They said that the last of the coastal lions had been killed a few years before and that instead of the numerous herds of black-faced impala that roamed the Kaokoveld a few decades ago, there were now maybe 200 impala in the entire region. The professors had been to Epupa four years earlier when there had been no permanent Himba settlement at the falls. The Himba came here for water sometimes, they said, but now a lot of them live here. It's like the American Indians, one of them commented, gravitating to the forts, picking up alcohol and Christianity.

A French photojournalist arrived at Epupa Falls and he said that it was the same story all over the world. His name was Pierre and he had been photographing indigenous people for fifteen years. Everywhere he'd been, he had encountered the same situation, traditional cultures weakened by industrial development, alcohol, and drugs. He said the Himba were the most traditional people he had seen yet. "They eat well here," he said. "They're not under demographic pressure. Their culture is still strong. Nevermind that Coca Cola is here, it's everywhere."

Pierre talked about the gap between what he saw in the field, and what the magazines did with his pictures. A tribe he stayed with in Thailand had been pressed into service as opium runners by powerful drug lords. Many people were addicted to heroin and AIDS was rampant. In one day he watched a man of twenty-six and a child of eight die of the disease. Using his photographs, a magazine back in Europe had made a story about a tribe practicing the traditions of their fathers; one paragraph mentioned social problems. Pierre said the magazines make dreams for people with grey lives.

Emergency

In the middle of a hot afternoon, when we were swapping stories with Jako and Pierre in the shade of the palm trees, a man walked into our campsite with his wife and young child. He said the border guards had told him to come to our camp and he held out a wounded hand for us to see.

The man had cut into his hand while chopping wood and sliced between thumb

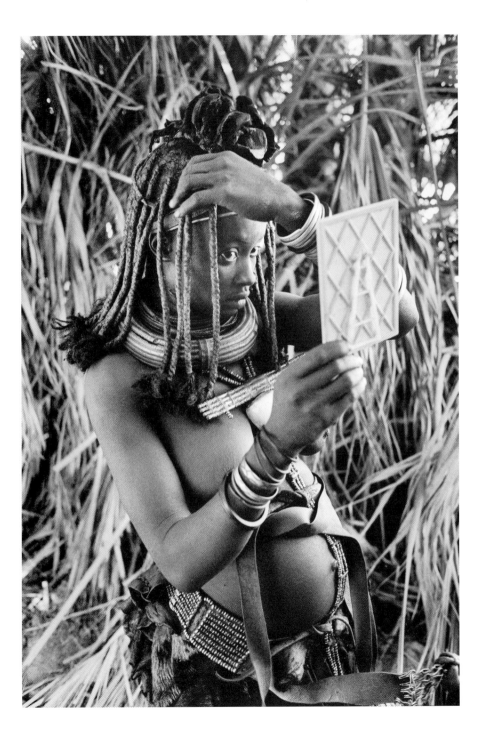

and forefinger almost to the wrist, leaving a gaping cut that was full of sand. The family lived half a day away from Epupa Falls and had walked to get here. Jako pulled out his medical kit and set up an examining room on a blanket. When he asked the man to move the thumb, nothing happened. The tendon is probably severed, he said. The man sat without flinching while Jako probed the wound, then spent most of an hour cleaning out some of the sand.

"There is nothing more I can do," Jako said, looking worried. There was no point in stitching it up as what was really needed was surgery to reattach the tendons. Jako said the only way the man might get the use of his hand back was if he got to hospital as soon as possible.

The hospital was in the big town of Opuwo, the place the liquor traders came from, the administrative capital of the region, a half day's drive down the road. I thought of Karamata's desire for a truck so he could take his children to hospital as we drove the man, his wife, and their child, towards the technology that would give him back his hand.

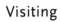

Visiting

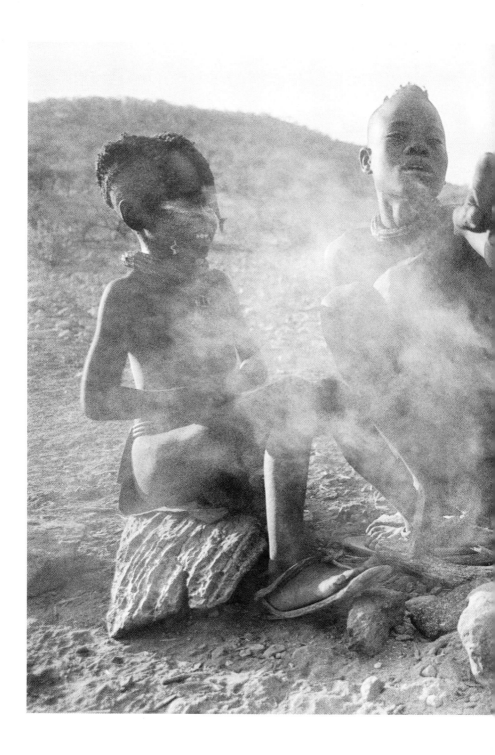

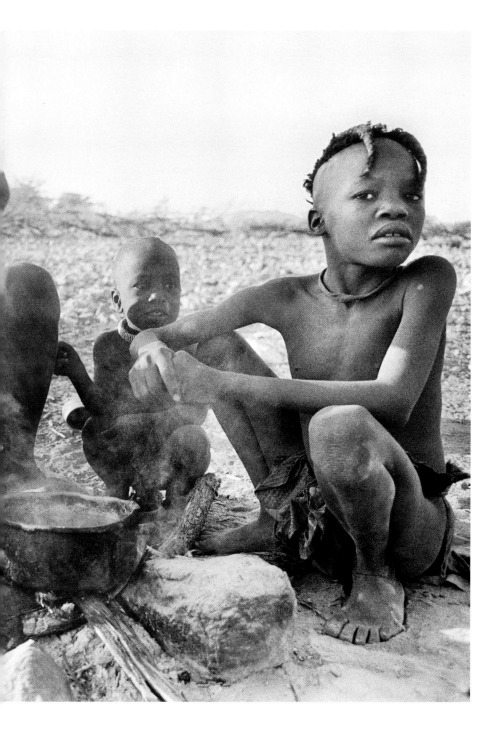

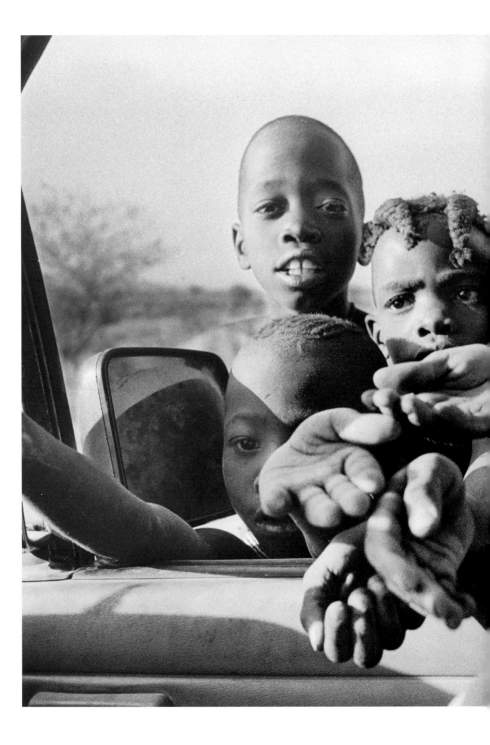

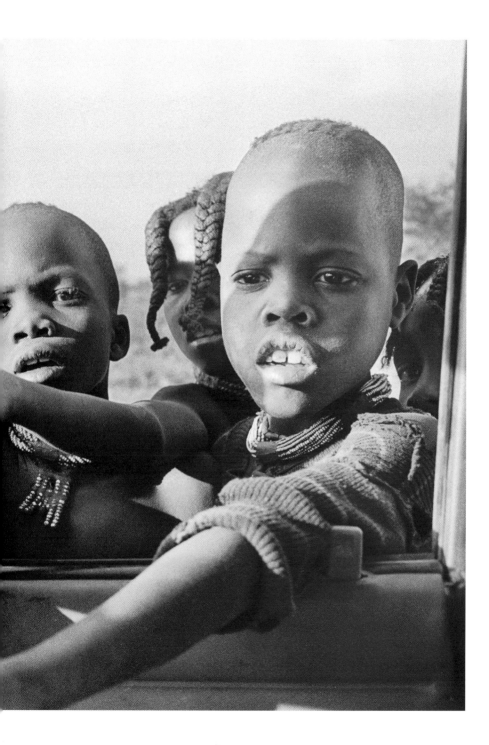

OPUWO

We were stopped before we reached the town by a group of kids who had stretched a length of string across the road at waist height. They wanted candy and money. Otherwise the drive to the hospital was uneventful.

We stayed in town after leaving the man in the care of a well-starched nurse, and it was here that we met the Belgian anthropologists. They were a couple about our age, and had been living with a family in a remote village for a year. This was their second stay. On their previous visit, they had used donkeys, but the problem with donkeys was that when they weren't in use, they were left to wander, and finding them again sometimes took days. Trucks didn't wander, but dealing with breakdowns could be as much of a problem as hunting for donkeys. They were in town for repairs and to load up on supplies.

We spoke with the anthropologists several times and learned there were half a dozen anthropologists working in the area. One night we went to the disco where we drank beer with them and danced, and on the walk home, they invited us to visit them at their camp. Almost two weeks had passed since we had come to Opuwo and delivered the man with the cut hand to the hospital. He had been taken to the capital and doctors there had reconnected the tendon in his thumb.

We had stayed in Opuwo because when we walked its streets we felt like we were seeing into the future. We had taken to calling this town of 4,000 the "contact zone." Students in white shirts mingled with Himba women in traditional dress. There was a big warehouse store where tourists in khakis waited to pay for their purchases along with women dressed like Maria. It was a frontier town, a place where conflicting norms and interests walked the same streets. It was the front line of change, a place where the world of the Himba and the wider world that we represented were pressed up against one another.

We had spent our time in Opuwo watching a lot of drinking, and now the idea of returning to the bush was appealing. It felt like a chance to leave the harsh confusion of the future and escape to the tranquility of the past. That feeling held a typical western bias; Opuwo wasn't the future, the bush wasn't the past – they were both present realities – but our feelings came straight out of the belief that history travels in a line and that our way of life is at the most advanced end of that line. From this point of

view, other ways of living are often described as being from the past, even when they are being practiced in the present. We had enjoyed being out in the village where the norms of the Himba were still dominant. Life was quieter, slower, and further removed from the world of cars and pop cans that I knew so well. I wanted to go back to the village and liked the idea of doing so in the company of English-speaking experts.

ETANGA

The village where the anthropologists where staying lay on the far side of a mountain range and the road had to be descended in first gear, one rock at a time. These low mountains were the quietest place we had visited, and the first where four-wheel drive might have been useful. In early afternoon, we came round a corner and saw the town of Etanga spread out beneath us: a few scattered huts, a couple of small square buildings, and what looked like the anthropologists' truck coming along the road. The anthropologists were surprised to see us and said they hadn't been expecting us. They explained that their truck had developed a new problem, and they had decided to get to the mechanic in Opuwo before it broke down in the middle of nowhere. They would be back within the week, and if we wanted to hang around town, they would take us to their village when they returned. They said to visit the headman of the area and obtain his permission to camp. Then they got in their truck and drove away.

Not knowing quite what to do, we drove into town. By the time we got out of the truck, everyone in the vicinity had gathered. They wanted to know where we were from, asking the question in Herrero and in Afrikaans. Where were we going? What were our names? Did we have a cigarette? A young man wearing aviator sunglasses and a camouflage jacket pushed his way through. He was about twenty, spoke English, and introduced himself as Kanguti.

We explained that we wanted to stay for awhile and Kanguti offered to give us a tour. David got his cameras together while I looked for the dog's leash. Every village had a few scruffy dogs who slept in the dust and got rocks thrown at them when they got in the way. Me and my dog, attached to one another by a leash, got stared at a lot. Our dog was big enough to frighten people, and young enough to run off and cause trouble,

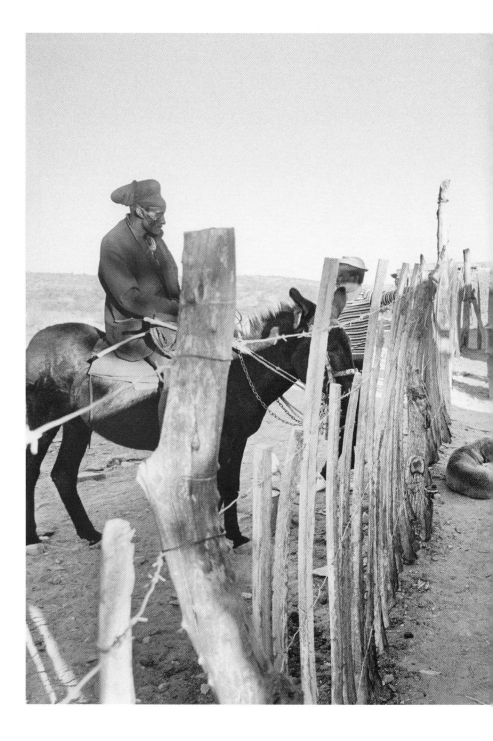

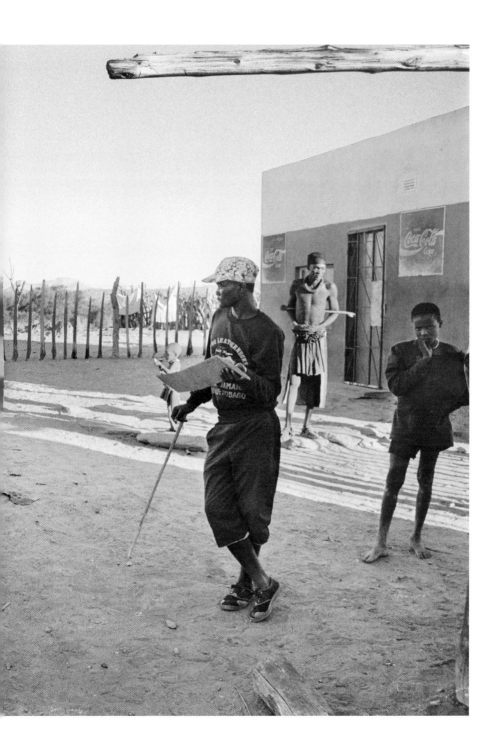

but the real reason for leashing him was to keep him out of the photographs. I couldn't find the leash, so asked David to improvise something, and the crowd moved with him to the back of the truck, and watched as he pulled aside the curtain and revealed our supply cupboard. When he cut off a length of cord, the man sitting on a donkey spoke up, and Kanguti told us the man wanted some cord to make a bridle. David cut him some and we headed off on our tour with a large crowd in attendance.

Etanga lay beside a wide riverbed that, like most rivers in Namibia, ran above ground only in the rainy season. The general store was built on a rise above the river and the small clinic and two-room school were down the hill. That was pretty much the whole town. Kanguti explained that most people lived in traditional villages, the closest of which was a ten-minute walk away.

We walked back to the store and Kanguti told the men drinking beer out front that we wanted to meet the headman. They said the headman had gone back to his village and suggested that we take a gift when we went to see him, and that what he liked best was snuff and sparkling wine.

It was dim inside the store and after the bright sun of the afternoon, it took a while for our eyes to adjust. There was a counter in one corner. The wall decorations bore the familiar red and white of the world's favorite beverage. The shelf held bottles of cheap South African wine, packages of ground corn, bags of tobacco, matches, and not much else. There was a lot more stuff in the back of our truck, confirming the feeling I'd had that, for many people, we were the store.

We had been gone for over an hour by the time we returned to the truck. As we approached, we could see that the back flap of the canopy was wide open, and realized that we had forgotten to close it. My first instinct was to rush ahead, but I restrained myself, and walked casually around to the back of the truck, and when I looked inside, I saw that nothing had been touched.

FUNERAL

We were going to the headman's village and had been walking steadily uphill for half an hour, sweating under the winter sun. The village lay on a plateau and remained

hidden until the moment we stepped into it, right in front of several dozen men who were sitting cross-legged on the ground. They stopped talking and watched as we stood there, catching our breath. The huts behind the men were large, and the village looked impressive, like the home of an important person.

Kanguti stepped forward to greet the headman, a middle-aged man who had an air of authority. Kanguti relayed to us the headman's short speech of welcome in which we were thanked for coming to meet him. David and I nodded and smiled at the men around us, none of whom smiled back.

We had taken the advice of the men in town, and brought tobacco and sparkling wine. When David put our gift forward, the headman told Kanguti that we should give it to his father, and pointed at an ancient man sitting on a decaying lawn chair near the center of the circle of men. With Kanguti beside us, David and I knelt in front of the headman's father. My eyes were at the same height as his bony knees; the hands resting there were long and thin and bent as if by the wind. David explained where we were from, and that we were honored to be there, and that he would like to take some photographs so that the people back in our country could see how the Himba live.

The old man nodded as Kanguti relayed David's words, and then the old man made a speech which Kanguti translated. "The white man comes with power. He has more power than the black man. When the white man came, the black man lost his power. We are glad you are here with your power." Our gift of sparkling wine and tobacco lay near the old man's feet. "Dankie," the old man said, using the Afrikaans word for thanks and giving us his blessing. "Okuhepa," David said in reply, using the Herrero word for thanks. The men around us repeated the word, *okuhepa, okuhepa*, and laughed.

Kanguti informed us that we had arrived in the middle of a funeral for one of the women of the village. The men were about to kill a cow for the feast, but first they were holding a council to discuss problems in the area. David took photographs as the men talked. Kanguti listened for awhile, then moved over beside me and said that two young men from the area had been stealing goats to buy alcohol. The decision of the group was that the fathers of the culprits would pay for the stolen goats, six goats for each one that had been stolen. Justice, Kanguti told me, was paid out in animals. Hurt a man,

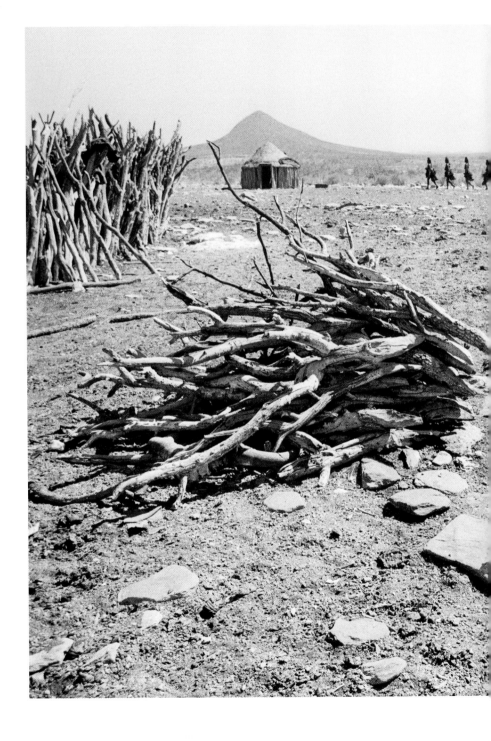

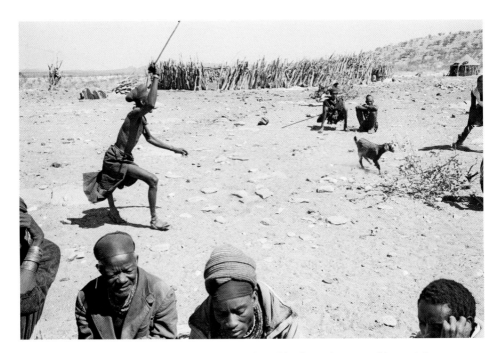

make him bleed from the head, he said, and he figured you would pay eight cows.

The men were also discussing whether or not to build a cattle dam that would ensure a regular supply of water for their herds. A scrap of paper was passed around with two numbers written on it: $400,000 and $120,000, the prices for the two options being considered. I was told that the larger dam would cover four kilometres. I was unclear about the location of the dam or where the money would come from to pay for it but, in the end, Kanguti told me that the choice was made in favor of the cheaper dam.

After awhile, some of the younger men left the discussion and went into the cattle enclosure and came out leading a big red cow with horns that easily spanned six feet. I watched as one of the man planted his thumbs in the cow's flared nostrils. Two of the strongest men then twisted its neck, until the animal fell over. Once the cow was lying on the ground, the men knelt side by side and their thighs flexed as they pushed their knees into the cow's throat, blocking its windpipe. The animal struggled at first, the back legs flailed, then the cow lay still for long minutes of quiet suffocation.

Once the animal was dead, its belly was slit and the organs, released from their

skin casing, spilled onto the ground. The headman came over to examine them. Another elder joined him, the young men crowded around, and everyone stared intently at the thick loops of exposed intestines. David moved into the circle and began taking pictures but several of the young men interrupted him, holding out their hands and asking for money. They wore T-shirts above their skirts, and their demeanor was challenging, several generations removed from the gentle look of the headman's father. The entrails waited while David emptied his pockets and gave all the coins he was carrying to a young man in a suit jacket who then divided the money. Seven dollars in change kept him busy for as many minutes with everyone arguing about how to make sure each of them got their share.

Once the coins were divided, the headman took a thin stick and probed the folds of tissue and fat, reading the fortune of his community in the entrails of the cow. I thought about how the cattle's economic significance was mirrored by their central role in spiritual practices, and wondered what the anthropologists could have told me about what the headman was doing. The young men crowded around him, and just before

noon one of their digital watches beeped out the time. By quarter past the hour the headman had finished reading the guts of the cow and four more wrist watch alarms had gone off.

While the young men were cutting the cow into pieces, the headman came over and squatted down beside me. The wind was blowing and I was trying to keep strands of hair out of my mouth and away from my eyes. He held a hand-rolled cigarette and gestured for a light. I passed him my lighter and moved my hands to block the wind for him. He got his smoke going in one try. We smiled at one another and I felt, for a brief moment, like I belonged.

One of the young men handed David a big piece of meat. The rest of the animal was being shuttled, hunk by hunk, over to large metal drums that looked like they had once held fuel, but were now on the fire, full of boiling water. Our piece of meat hung thick and bloody from David's hand. We decided to take it home and make supper. It was a welcome gift as we hadn't had meat in over a week. The rest of the afternoon we devoted to cooking a stew. Kanguti went off and got his brother, some of the kids from the local school showed up, and a few hours later we served our own feast.

SHOES

Kanguti's feet showed through the broken stitching of his leather loafers that were a couple of sizes too big. People who had adopted western clothes wore whatever kind of footwear they could get; the size, style, and state of repair didn't matter. When we got back to camp after visiting the headman, David dug out the sneakers he had brought for the jogging that he hadn't been doing and gave them to Kanguti who immediately sat down, pulled off his loafers, and pushed his bare feet into the sneakers. Etanga was a quiet place, and Kanguti hadn't asked us to pay him for translating. There were no tourists around, no other white people in the region except for the two anthropologists. I think we were entertainment for Kanguti. He hung around our camp constantly, drinking tea and sharing supper. On our visit to the headman, Kanguti had been wonderful and seemed to enjoy being at the middle of the conversation, acting as translator. We had been fortunate to have him as our mouthpiece and the sneakers

seemed a good way of saying thanks. His brother inherited the loafers and Kanguti walked around with a purple swoosh on the side of his feet.

MEETING TREES

At seven o'clock in the morning, the sun was bright, the air was freezing, and I was in bed under three blankets with a toque pulled over my ears. When I finally poked my head out of the truck, I looked right into the unblinking yellow eyes of a large owl. The owl was on the bottom branch of the nearest tree. Our camp was along a dry riverbed, just over the hill from the village. There were birds up and down the riverbed and three huge trees stood testament to the fact that, while no water was visible, it was there beneath the ground. Kanguti had called them *meeting trees.*

The kettle had just boiled for tea when the first visitor arrived. After the exchange of greetings, he thrust out his arm to show his wristwatch. It read 20:04 – exactly twelve hours off. David bent over the man's hand in what had become a regular ritual between him and many of the men we met, aligning their time with the rest of the world. By nine a.m., the air was hot, and when I stepped beyond the protective shade of the meeting trees, my ears began to burn in the sun. The next man to arrive wore shorts and carried a skinned goat carcass over his shoulder; he asked for a cigarette and two dollars. He stayed for tea too, doing as the others had done and putting heaping spoons of sugar into his mug. The sound of pop music reached us and a man in pleated trousers came into view carrying a radio playing an African version of a '70s disco tune.

The shady ground under the meeting trees had become our living room and the world moved through it freely, sporadically, unannounced. People came over when we started to cook and stayed until we shared a meal. Kanguti, his brother, and the boys from the nearby two-room school spent many hours leaning against the tree, sometimes talking, sometimes just watching us. One afternoon, I wrote in my journal with four pairs of school-boy eyes following every move of the pen. The next morning, several young mothers arrived and settled down in the shade of the trees. One of them grabbed the teat of a nearby goat, picked up a beer bottle from somewhere, and

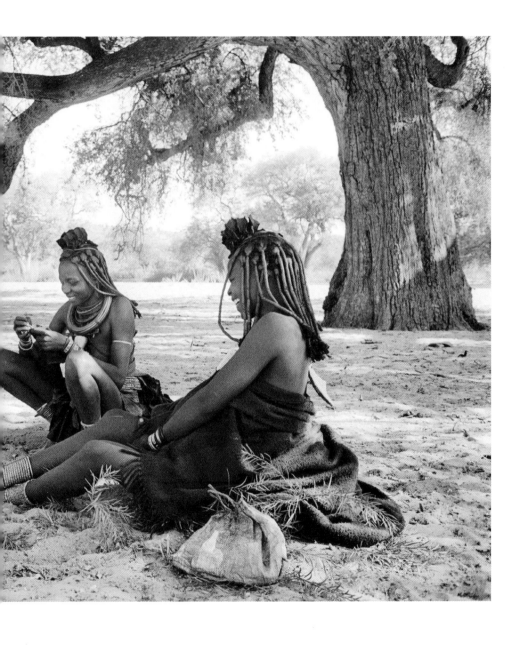

squirting milk into the narrow opening, filled it and drank.

Most of our visitors were men; those who stayed the longest seemed to be the young ones caught between cultures. They were usually wearing western clothes, tight t-shirts, tattered shorts. When they asked for things, their tone was sometimes belligerent, and there was often a hardness in their eyes. Later, I would read about these footloose young men in American anthropologist David Crandall's book about the Himba. He writes about the rise in cattle rustling and how, in regions where employment opportunities are rare, cattle theft is one of the few ways young men have of obtaining the money required to buy things.

The most common requests we got were for cigarettes and soap, candies and ground corn. Money was popular, as was our truck. We were asked for rides two or three times a day. People wanted my shoes and my shirt. "I'll give you a goat for that," one man said, pointing to our only lawn chair. Offers to trade were rare; usually we were just asked to give things away. The goat sounded like a great deal and if the chair hadn't belonged to my mother-in-law, we would have eaten it that night.

School

Word of our arrival reached the school before we did and a dozen students were outside waiting for us, ranging in age from six years old to their mid-teens. They were mostly boys, dressed in clean t-shirts, who knew enough English for a conversation. We told them we were from Canada, which didn't get much response until we explained that Canada was next to America, and then they all nodded. A young, bright-eyed kid asked for pens and we promised that if they came to visit our camp site, we would give them some.

The boys arrived in the afternoon when classes were over; they had changed into shirts full of holes and tattered shorts. The oldest, the one who seemed to the leader of the group, was named Eddy, fourteen years old and in Grade 3. His parents didn't want him to go to school, he said. His father had said to him, Why go to school? What is learning? Who will look after the cattle and the goats? The children explained that for most of their parents, school meant the kids weren't able to help with the herds because

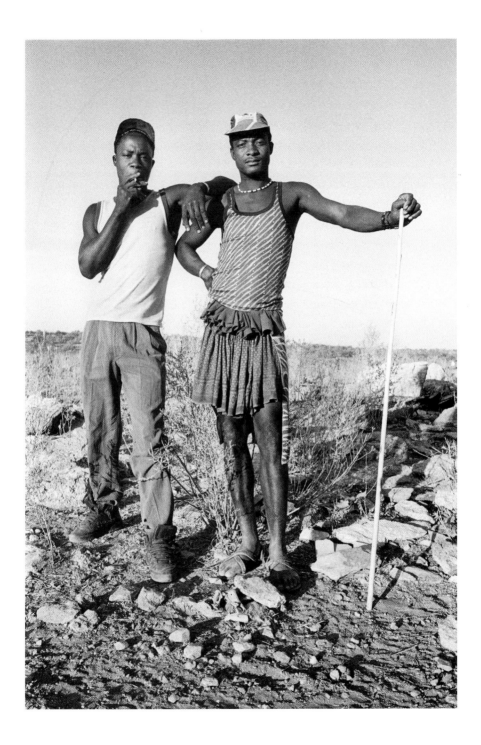

they were away from their families, learning to read and write instead of learning to find the best grazing or water. Sometimes their parents took them out of classes for weeks or months at a time to move with the herds to distant cattle posts.

Hours later we walked them back to the school and they showed us where they stayed in a shed of corrugated tin that was home to a dozen children. The floor was concrete and there was a single bed frame pushed up against the back wall with a board lying on it instead of a mattress. Most of the kids slept on the floor. They each had a set of good clothes that they kept for school, and these, along with three blankets, were hanging from the ceiling.

The school consisted of two classrooms with desks and chairs lined up in rows. Beside a picture of a smiling Dr Sam Nujoma, the president of Namibia, there hung a poster showing different kinds of land mines, grenades, and mortar shells. "These bombs will kill!" the poster read. There was graffiti on the walls, one a drawing of a Volkswagen bus with the words "Face it baby" written beside it.

In my frame of reference, education had always seemed like an unmitigated good, yet here its benefits seemed ambiguous. Later, in a report submitted by a Namibian lawyer to the World Commission on Dams, I would read: "One perception is that a low level of schooling may lead to dissatisfaction with the Himba way of life while not equipping youth with marketable skills – with the result that a school-leaver ends up as a low-paid wage laborer rather than a self-employed and relatively wealthy herder." Eddy came to mind when I read this. Our conversation under the meeting tree that afternoon had turned to his ambitions. The reason he was at school was because he wanted to be a movie director. He was full of pride when he said this and the younger boys looked at him with respect. He was here, at age fourteen, studying to pass Grade 3, because he knew he needed to learn to read and write in order to direct movies.

MAGIC

The healer was from Angola and specialized in curing people who had been cursed. The men who gathered to drink beer in front of the store had told Kanguti the doctor was coming, and when he arrived, Kanguti helped make the arrangements for David to

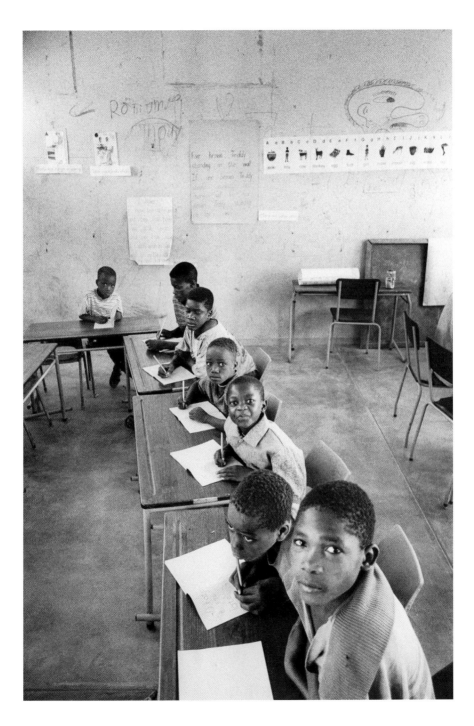

photograph a healing. It cost twenty dollars and a pouch of tobacco.

We had first heard about curses from a doctor at the Opuwo hospital, who told us there was a high level of anxiety among his patients because they feared that they may have angered their ancestors. He said the dead who are unhappy with the living

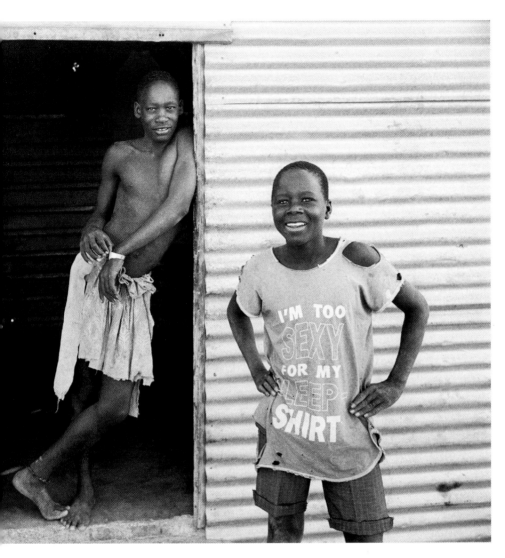

can curse them, and related the story of a young woman who left home after hitting her mother. Sometime later, when her mother died, the daughter took sick, saying she was cursed by her mother, believing that her cure, her release, would come only with death. She died eventually, like other patients the doctor had seen fail without any

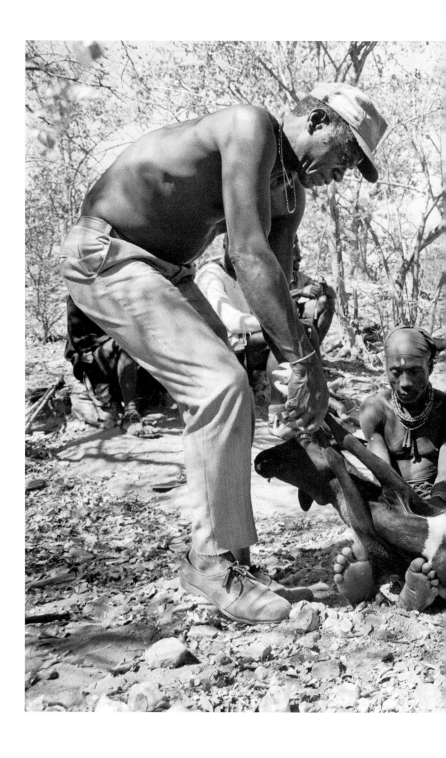

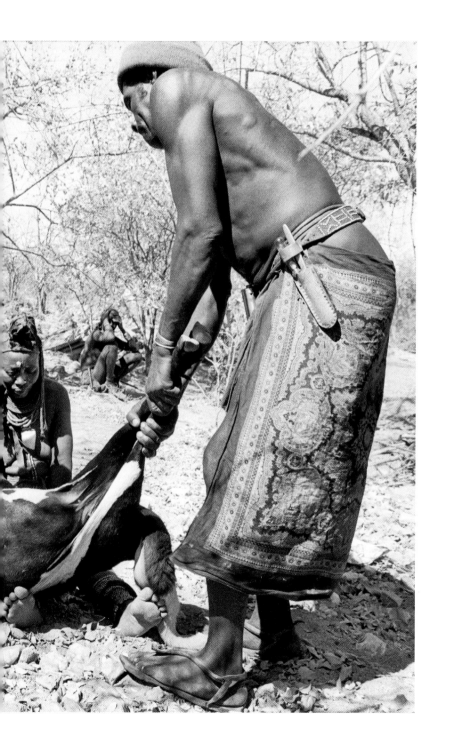

reasons that his medicine could discern. One of the Belgian anthropologists was doing fieldwork on witchcraft and had explained to us that anyone, alive or dead, could place curses on others. There was rumored to be a growing trade in the sale of magical spells to make people rich and these were said to sometimes involve causing harm to anyone standing in the way.

The Angolan healer was a thin man with a serious face; he wore a New York Yankees ball cap and a land mine T-shirt that read "Don't Touch It! Report It!" The patient was a man of about forty-five who had been feeling ill for weeks. He believed he had been cursed, and if it wasn't by someone living, maybe a friend or family member who was angry or jealous, then it could be the curse was laid by an ancestor whom the man had managed to offend, perhaps by failing to perform a special ritual in his honor. The man believed he would stay ill until the source of the curse was identified and a cure prescribed. Kanguti told me that, just as our doctors look in a book, this doctor looks in the meat of animals to find the medicine required to heal his patient.

We left the man's village and headed downhill to a spot near a dry streambed. The patient sat next to the doctor, surrounded by family and friends, me, Kanguti, and the hovering photographer. The goat lay at the center and the doctor began by pressing his knee into the animal's throat and strangling it. He then picked the goat up by the ears, opened its mouth, and looked at its teeth, all the while pointing and talking. Everyone listened intently. I felt too shy to ask Kanguti for a translation, so the scene played like a foreign movie without subtitles.

The doctor opened the goat in layers, going through the skin, into the tissue, and finally down to the organs. Once he had cut into the abdomen, his hands worked around the rib cage for many minutes, pulling organs out of the animal, and laying them, still attached by sinew and tissue, to one side. The men moved in closer. I moved back, beyond the shade of the tree and into the midday heat while the doctor unraveled the goat. The healing had been going on for over an hour. Up in a cloudless sky, the thin white line of a contrail indicated an airplane passing by overhead, so high up that the sound didn't reach us.

GIVING

The anthropologists returned after five days. Their truck was fixed; they were going back to their village and invited us to follow them. One of the first things they did upon arriving back at their village was make a fire and put the kettle on for coffee. A short while later, everyone in the village was there: wives, children, the headman, his teenage son, and several men in T-shirts who turned out to be visitors. I noticed that the headman was staring at me. He spoke and the anthropologists translated: He thinks you should go to bed with him, they said. I blushed. He was an older man, his face suggested he was easily sixty, though his bare chest and arms looked stronger and sexier than those of my thirty-year-old husband.

Please tell him I'm married, I said.

His reply was, That doesn't matter, so am I. He continued to look at me and everyone in the circle laughed.

The anthropologists fed us pasta and tomato sauce for supper. We sat by the fire late into the night. The stars were spread above us and when we weren't looking into the flames, we were staring at the sky. I told them about the time that we had been talking with Karamata about traditions, comparing their marriage and funeral rituals with ours. We had had trouble explaining the complexities and permutations of our societal behaviour with its breakdown of family and religious norms.

"You have no culture," Karamata had said, and I had been caught by his words because sometimes it really felt like that. Everything he and his family did was their "culture"; ours seemed pale in comparison. The anthropologists agreed that our traditions did seem thin when compared to the ones being lived around us. They had also found that our marriage rituals sounded insubstantial when explained to people who changed their village, their hairstyle, and some of their clothing when they got married. The value of gold and the worth of a diamond were hard to explain. The culture of the Himba seemed more meaningful, almost more real than our own.

The anthropologists were studying adornment practices and talked about the way in which jewelry, butterfat on the body, and the arrangement of space within the village, were all integral parts of the Himba world view. This was another area where I felt our practices were lacking in meaning, or at least any articulated meaning. I put on

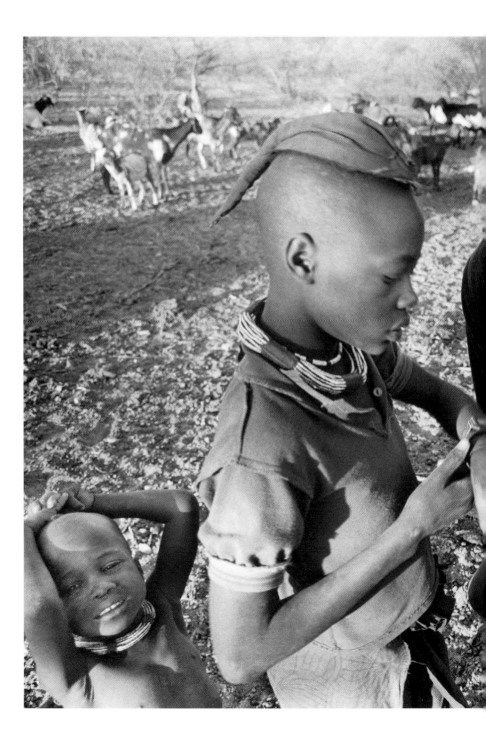

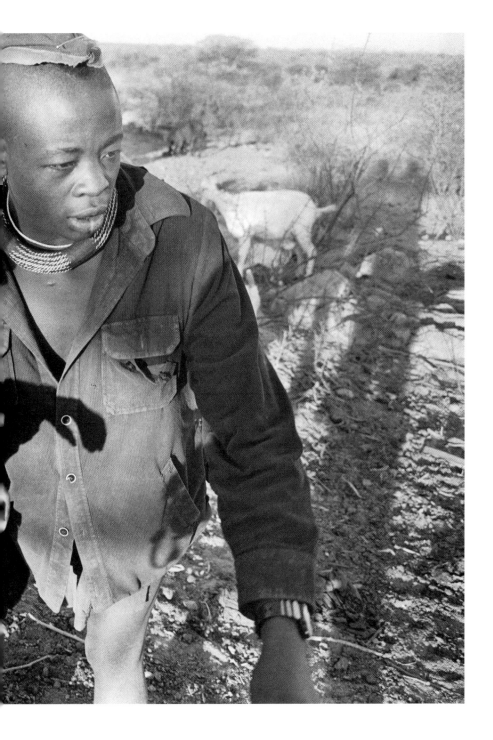

trousers because they were comfortable and not because of the message they relayed to those around me. I didn't know where they came from or who made them. Maria knew that her headdress meant she was a married woman. She had known the goat her skirt was made from while it was still alive. The butterfat she rubbed on her body came from the herd and the ochre she added to it made her skin gleam the color of her family's prized cattle.

The moon came up and some of the stars disappeared. The anthropologists warned us about romanticizing the Himba. They talked about how the people were good at herding, but were not very industrious, and joked about a small cattle dam that was supposed to be built, saying that if the Himba did it by themselves, it would take a hundred years. On a more serious note, they said they knew there were women who got beaten by their husbands. They didn't think it was a general condition, but more a matter of certain individuals who were mean. They had seen some bad treatment of animals and, in one village, had watched a man beat a donkey, then leave it to die by degree on the edge of the village for several days.

In the morning, the men stopped by for a cup of coffee and the usual four or five spoons of sugar. One of the women came over for a bag of salt, one of the young men asked for a pouch of tobacco, and each time the anthropologists went into the tent and came out with the requested item. They told us they kept a supply of things like sugar, salt, coffee, and tobacco for giving away and said that sharing was an essential part of social norms here. For example, travelers were always fed. You could leave your village in the morning carrying almost nothing and know that once you reached another village, you would get to share whatever the people were eating. The custom seemed to be under a bit of strain. The anthropologists had overheard the children complaining about how hungry they were because the young men who were visiting had drunk all the milk. I got the impression these young men were hanging around, taking the village for what they could get, and that they weren't going to be missed when they left.

We went for a walk to visit a nearby village where the doors of the huts were boarded up and the ash from the fires was old. It was a drought year and after the well went dry, those villagers had moved to a reservoir in the mountains that still had plenty

of water. The family the anthropologists were staying with had been able to remain in the village only because the anthropologists' truck made it possible to get water from a distant well. The sun was bright and the intermittent breeze picked up bits of fine dust and whirled them around. They told us that the Himba believe their ancestors live not just in the fire, but also in the rocks, the trees, and the wind. Spirit and wind, they said, are the same word. We only walked for an hour, but returned hot and thirsty, glad that it was still winter.

We stayed another day and on the morning of our departure, joined the usual coffee circle. The headman reached out, touched the narrow copper bracelet around David's wrist, and said something in a challenging voice. He wanted to know why David was wearing a bracelet that belonged to the Himba. David explained that he had bought it from a Himba man in the market. Then David reached out and touched the thick corduroy shirt the headman was wearing and asked why the headman was wearing something that belonged to the white men. The anthropologists only translated the part about the bracelet. The question about the shirt, they said, might be offensive.

Before leaving, David presented the headman with a large butcher knife from our kitchen supplies. The headman smiled and his thanks were effusive. He turned the knife over in his hands, said we were welcome in his village anytime, then blessed us, our children, and our children's children. Just before we got in the truck, he came in search of us again, wanting to know if we had a scabbard for it.

HEADMAN

We were disheartened when we left the anthropologists' camp. We had enjoyed the conversation, but it had reminded us of how little we knew about these people and this place. The anthropologists had an intimacy with the family that came from living together through the space of several seasons. Our insights seemed small and insignificant in comparison. The longer we stayed, the more our story seemed to unravel, and we wondered if we would have anything to say once we got home. One way of dealing with this was to get some words directly from the people themselves,

and we decided to visit the headman who was leading local opposition to the dam. His name was Kapika and he had been quoted in the news as saying, "They will have to shoot all the Himbas before they build the dam."

On the way to his village, we stopped at a town where there was a large school to pick up a young Himba man who we had heard was an excellent translator. His name was Cornelius, he was seventeen and in Grade 6, and he looked more like a teacher than a student in his silk shirt and pleated trousers.

I asked Cornelius what he knew about the dam and he told of a meeting that had taken place between Kapika and Namibian president Sam Nujoma. Cornelius said that Kapika played the big chief, and Sam Nujoma had told Kapika to remember that a president has more power than a chief and that if a president decides to build a dam, then the dam will be built. At that point, Kapika and all the Himba got up and walked out.

We arrived at Kapika's large and prosperous-looking village in the early afternoon and were met by two young men with big biceps. They told us to wait under a tree. Eventually, Kapika appeared and one of the young men hurried to place a lawn chair in the shade. Kapika shot a hostile look in our direction, then sat in his chair and turned his body away from us. David talked to the headman's profile, telling him we had traveled from Canada to find out what the Himba had to say about the dam the government wants to build at Epupa.

"Why should I talk to you?" Kapika said, his words more a statement than a question. He said that many people had visited him, slept in his guest hut, asked the same questions as us, and then gone away. "Nobody has come back to tell us what their government decided," he said. "It has gone quiet." His face was disdainful. "It is a problem for me to speak with you," he said and stopped talking.

David and I both spoke at once, tripping on the words as we tried to get Cornelius to explain to the headman that we belonged to a tribe that was so big, we didn't know the people who had visited him already. Those people had come from other countries but our country knew nothing of the Himba and their problems. We wanted Kapika to understand that if he spoke with us, maybe we could tell the people of Canada about the dam and the problems it would cause for the Himba.

Kapika cut off our flow of words with a question. "Who is your president?" he

asked. When we told him it was Jean Chretien, he shook his head. We had told him we were from North America, so I said, "Bill Clinton," and Kapika brightened. "Yes," he said, "that one, he came to see me last month and brought me a big knife."

This was getting weird. Bill Clinton had not been in Africa lately, let alone sitting under Kapika's tree. I speculated that Kapika's visitor had been the president of an NGO or maybe some traveler playing games. I asked if we could see the gift from the president and Kapika sent one of the young men to fetch a Leatherman-type tool that unfolded into a knife. David turned the tool over in his hand, opened it up, murmured appreciatively and, for a moment, the mood of the meeting was almost congenial. Then Kapika asked us where his pump was, saying that our president had promised to send a new electric pump for the borehole where the village drew water, but that it was now over a month later and there was still no pump. I assured him that if Bill Clinton had promised him a pump, he would get a pump, and this seemed to mollify him.

Again, I asked what he thought of the dam at Epupa, and this time he said, "I am Kapika the chief. Epupa belongs to me, to the home of Kapika." Then he recited an extended genealogy of the Himba families in the region, both in Namibia and across the border in Angola, who had claims to Epupa Falls. He said, "Epupa belongs to me, to the home of Kapika. It belongs to Bendura home. It belongs to Tjimburu home. It belongs to Tginge home." After each name, he paused so Cornelius could translate his words, and I could write them down. Before continuing, Kapika would ask Cornelius, "Did she get it?" Then he continued with the list of names. Once the genealogy was done, he said, "We are finished. This is the last word. Epupa will not be built as a dam."

I started to ask a question, wanting to hear about the ancestral graves that would be buried by the dam, wanting to know whether Kapika grazed his herds along the river, and curious to hear what he thought of President Sam Nujoma, but Kapika waved my words away. I fell silent, dismissed. David asked if he could take a photograph and Kapika agreed, remaining in his lawn chair, looking haughty. After a few frames, he waved his hand again, got up, and walked off.

We were headed for the truck when Kapika called after us. Cornelius said he wanted us to take a look at his finger. There was a sliver wedged in the top near the nail, and the skin was red, slightly infected. David used our tweezers to take the sliver out,

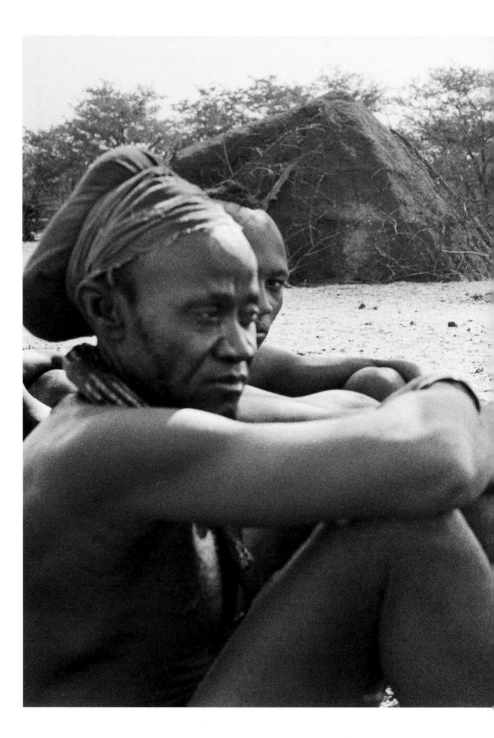

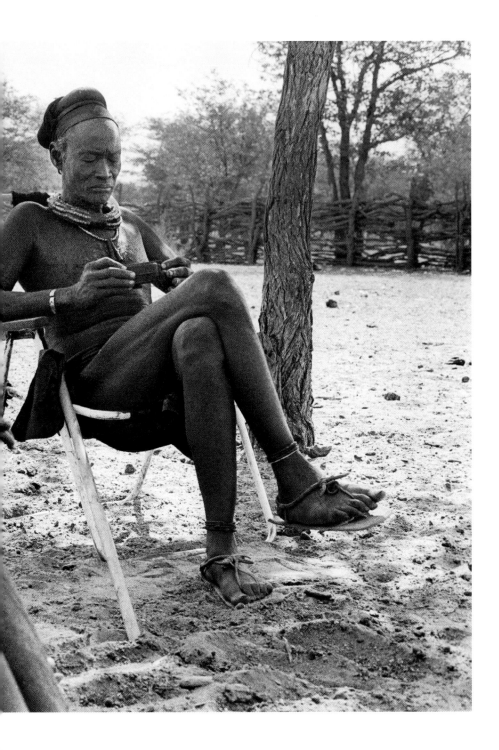

then applied disinfectant with a cotton ball, put on medicated ointment, and wrapped a Band Aid around it. Kapika held up his finger and smiled for the first time. "Give me that," he said, pointing at the Band Aids; we gave him the tube of ointment as well and left the village with his blessing.

As we drove away, Cornelius explained that his father was Kapika's uncle, which meant that Cornelius and the headman were cousins. I was surprised given the age difference between the two, but Cornelius said he was the youngest of his father's children. "Kapika is like my father," Cornelius said, "they are both naughty men." Kapika was being "naughty" with us when he said it was a problem to speak to us: he was playing games to see what we would do. Cornelius also said that Kapika is a rich man who has many cows and has already owned many trucks. "He will tell you he is poor and ask you to give him things, but it is not true."

DAM

Cornelius had grown up in a traditional Himba household, and his father was angry with him for going to school. "I escaped from my father to go to school because I wanted to be able to read and write," Cornelius said. "If I go to school, then I can get a job and make money and buy what I want."

He had already bought a camera. He explained that he worked as a photographer, taking photos of people in the area. David asked about film and processing and Cornelius said he had to mail the film to the capital, to get it developed and pictures printed. The money he made helped pay for his schooling. Cornelius and David talked about photography as our truck bumped along, slowing down repeatedly in order to pass cattle, and finally stopping to say hello to the young men herding the beasts. During the conversation, each of the herders reached out at some point and touched the digital watch that Cornelius wore on his wrist.

We were taking Cornelius back to his school. He was a wonderful translator and we felt it was unfortunate our conversation with Kapika had been so limited. Before we reached the town, we saw an older man standing along the road. Cornelius suggested we stop and talk to him, as this man was also a headman and would have something to say about the dam.

He was a man of about sixty, and was happy to speak with us, but refused to say anything until I had my notebook out and was ready to write down his words. He started his commentary on the dam by drawing a diagram of Epupa Falls in the sand.

"Now this is the river," he said through Cornelius, "and at the division of the river there are islands. Inside the islands, there are trees that we can use for the goats, cattle, and donkeys to eat during the autumn time. If you put a dam in Epupa, all this area will be covered with water. There will no more be a place for our cattle to graze. In the middle of the island, sometimes Himba die and we bury them in the island. We come back to commemorate them. This is important. We eat fruit from the islands also. Now the government of Namibia, they don't know about the Himba. If the dam comes and they cover this area, where are we going to graze? This is the main reason why we refuse the dam. This area will be under water and there will be nothing alive under there."

He said that all the chiefs of the area had refused the dam, and named several others besides himself who opposed the project. He said his people were poor and couldn't go to America to talk to the government there. He complained about how poor the government of Namibia was, and spoke about the time when Namibia was ruled by South Africa, that in those days the chiefs received 100-pound bags of ground corn each month, and the people were given blankets when they went to hospital. Now they must get their own blankets, their own mealie meal, and when the government has a meeting in Windhoek, the chiefs must get their own ride, their own place to stay in the city, their own food, and then get themselves back home again. He himself was just returning from a meeting in the town of Opuwo and he was waiting here hoping a ride would come along.

At this point, the man stood up and drew his finger across his throat in a slow menacing gesture. Cornelius translated his words. "It is serious that we will die because we do not farm with money. We drink the milk from the goats, we eat the plants. Even our wives, when they hear about Epupa, they want to kill themselves because they know our people will die."

We assured him that we would do what we could to make the people of Canada aware of the problems the dam would cause for the Himba. David asked if he could take a photograph and the man stripped off his T-shirt and windbreaker before

standing straight and looking into the camera. When I asked why he took them off for the picture, he said, "We wear these shoes and shirts only for the cold." We gave him a sack of ground corn, for which he thanked us profusely, and bid him farewell.

We had driven on for only a few more minutes when we saw two more men sitting by the road. Cornelius was happy to keep translating, so we pulled over. We told the men we were talking to people about the dam and they repeated much of what the previous man had said.

One of them had been to the capital and when I got Cornelius to ask him what he thought of the city, he said, "It is good to see with the eyes, but not to live. We are farming with our cattle. Where would they stay in Windhoek? We eat from the cattle, we must not stay in the towns, we are not for life in the towns."

DARKNESS

We dropped Cornelius off at dusk and set up camp as the sun went down. I made a fire and started to cook while the last light drained from the sky. One of the things this region had introduced me to was true darkness. For weeks now, the phase of the moon had determined the amount of light by which I cooked supper. I had given up my temperamental flashlight and learned how to organize myself on dark nights so that I could cook by fire light, remembering where I placed things when I put them down, keeping my tools to a minimum.

I had taken an astronomy course at university, but it meant little compared to the education in lunar cycles that two months of living beyond the power grid was giving me. The word moon took on a whole new range and depth of meaning when I experienced it without interference from the technologies I had grown up with. Until now, my understanding of night had been mediated by electric lights.

The moon had been full when we arrived in Kaokoland and its brilliance astounded me. I could actually read by it. The rocks and hills appeared in soft greys and browns, and I felt like we had entered a universe parallel to the one lit by the sun. Moonlight was great for traveling and when we were camped near trails we would hear people walking past, using the nocturnal sun to advantage.

On this night, I knew the moon wouldn't be up for hours yet. The inky blackness folded itself around everything and made the fire into the center of our existence. I was cooking ground corn in one pot and making gravy in another, balancing them on a couple of rocks, when the dog growled and a man walked into the circle of light. He was old enough to have been around during the war and spoke a little Afrikaans. He said he was a Zemba, one of the smaller tribes in the area, and lived nearby with his family. He settled down by our fire and he and David talked while I finished cooking.

I served our visitor first and after one bite, he started to sputter and cough. I had dumped too many dried chili peppers into the gravy. David assured him that I had not been trying to kill him and when we began eating, the man tried again, coughed a few times, and eventually got through his plate.

We sat by the fire and while the men talked in Afrikaans, I thought about the dam and what it would mean beyond the flooding of graves, the loss of grazing, the influx of workers and commerce. Back in town we had run into a well-dressed man with a big-city air about him who told us he was from Windhoek and that he worked for Namibian television. I asked what he felt about the dam and he had said, "We must develop these people. We can't do it without electricity. If we don't, if we leave them, then maybe in twenty years they will revolt and say, why do you develop all the other areas and not us? We must develop them, educate them, give them electricity so they can live a normal life."

I stared into the darkness beyond the fire and thought about the way electricity had limited my experience of night. The stars, the moon, the darkness had all been made pale, and sometimes almost invisible, by my "normal" life. Technology buffers us from the world as it is given. When the Himba are on the power grid, night won't be as dark, nor will the full moon shine as bright. When we finally put the fire out, the darkness that climbed into bed with us was more comfort than threat and I felt lucky to be there.

I was up at five a.m. My body had begun to respond to the sun, stirring into wakefulness hours earlier than I had ever willingly risen. I started a fire, put on the kettle, and held my fingers to the flames as the sun rose and the temperature took its just-after-dawn dip. I had never known such calm pleasure in waking. This regular

contact with fire and earth would be among the things I missed most when I returned to the world of alarm clocks and coffee shops. The man from the night before appeared and gave me a Rhumba Appertif bottle half full of milk, still warm from the goat.

CHURCH

On Sunday Cornelius had asked us to come to church with him. He met us at the front gate of the school wearing a tie and carrying a bible. We walked across a field to the little white church with several of his classmates. Folding chairs were set up in rows on the concrete floor. Cornelius introduced us to the born-again Christian minister, an African man dressed casually in a checkered shirt, and explained that David wanted to take some pictures during the service.

The church was about half full, the women in dresses, the men in trousers. A few children in ragged clothes came in, one of them wearing a T-shirt that read "My Fate to Skate" with a picture of a skateboarder on it. The service was conducted in Herrero. The first hymn was about Jesus being a friend, and then the minister prayed for a long time from the whitewashed pulpit. A few Himba women came in and sat down, their red breasts contrasting with the Sunday dresses of the other women. Cornelius came forward and his face shone with conviction as he delivered the sermon he had prepared, and then the tiny choir, consisting of Cornelius and several schoolmates, sang a couple of songs.

The chairs were uncomfortable, the morning outside was beautiful. Some of the children walked out and David and I followed them. We could hear voices raised in a rousing song coming from across the field where the door of another white-washed building was open. Inside, the room was packed with people dressed in Sunday best, swaying together on the plank benches. A woman waved for us to join them, but we backed away. As we circuited the town, we counted four church services underway.

PARTY

An old Ford truck with a dented hood and bald tires was parked near one of the town's

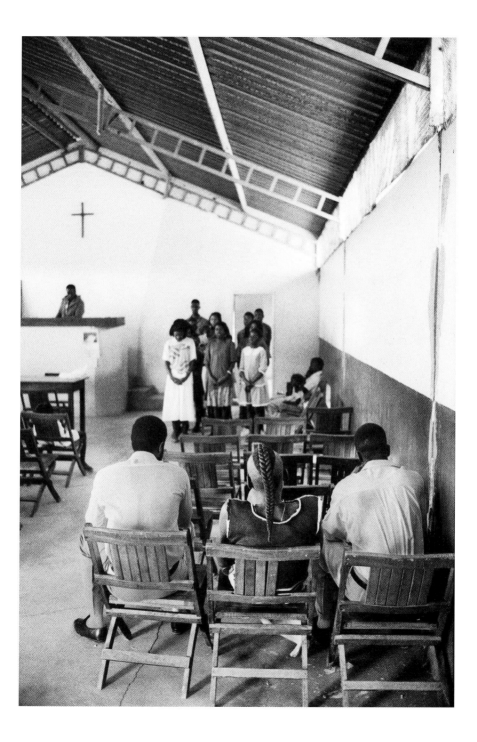

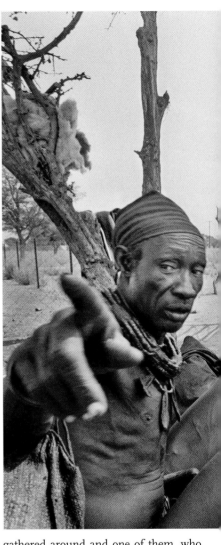

two stores. A group of men and boys were gathered around and one of them, who turned out to be the driver, recognized us from the funeral at Etanga. He spoke some Afrikaans and, as he flipped his car keys from one hand to the other, he told us that all these people were traveling with him, and were on their way to Opuwo to go shopping for ground corn. Some goats were tethered in the back of the truck and, when I asked,

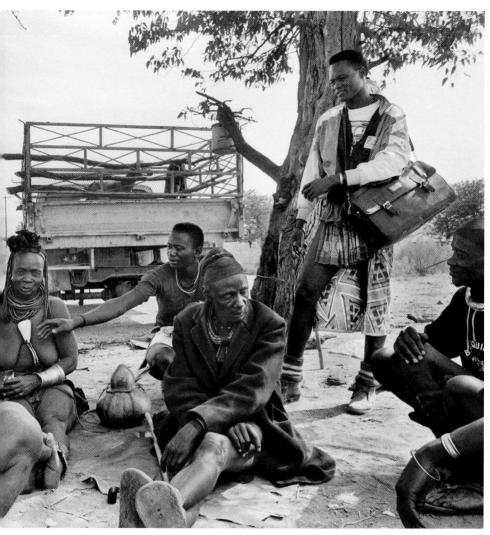

he said they were food for the trip. He said the truck belonged to his father and I thought about how full it must have been when he drove in here, loaded with four goats and, on a quick count, about sixteen people.

A middle-aged woman was seated under a nearby tree with the older men and a bottle of cane spirits. Nobody seemed to be in a hurry to get going. David asked if

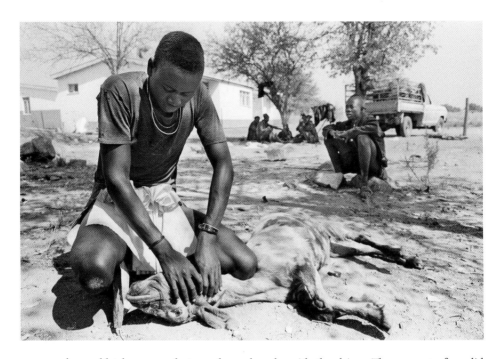

he could take some photographs and spoke with the driver. The concept of candid photography wasn't an easy thing to communicate, so the conversation went back and forth for almost half an hour before a price of twenty dollars was agreed upon. David handed the money to the driver who immediately called all the people over, and before David could object, had them all standing in a line in front of the truck, staring at him. David clicked his camera, then went back to talk with the driver again. Eventually, he found it easier to demonstrate what he meant; he crouched down on the edge of the circle of drinkers, talked to one of the older men in his smattering of Herrero, got a few laughs, and took some photographs. The woman was the center of the group, the bottle of cane spirits in her hand. She poured some of the clear liquid into the makeshift tin cup and handed it to David. He took a swig, passed it back, and said *okuhepa*. Everyone laughed.

The young men stayed on the periphery of the drinking, playing with their walking sticks and staging mock fights. After an hour or two, the woman sent them to the store

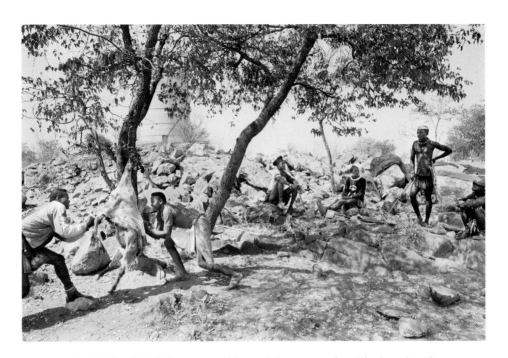

to get another bottle of alcohol. It was midday and the sun was hot. The boys bought some orange pop for themselves and retired to a shady spot on a rocky knoll littered with broken glass, probably from previous parties. The drinking continued and when the oldest man, who was perhaps seventy years of age, passed out and wet himself in the process, two of the young men took care of him. They put sand on his blanket to dry up the piss, then gently lifted the old man and carried him over to a quiet place in the shade, taking care to place a rock under his head for a pillow.

ANOTHER EMERGENCY

During the hottest part of the day, one of the young men pulled a goat out of the back of the truck, grabbed it by the horns, led it over to the shade, pressed his knee into its throat, and killed it. Then they hung it from a tree branch and two of the young men grabbed hold of the skin, and leaning into the task, pulled the skin off to expose the meat.

The goat was still boiling on the fire when a small truck pulled up with three white people squished into the cab, the back full of Himba women and babies. The driver jumped out and asked for the doctor. One of the women in the back was very sick. She was young, her eyes were closed, a blanket was draped over her limp body, and she lay in the arms of another woman who was wailing mournfully. The driver said that he and his friends had been vacationing at Epupa Falls when the women asked them for help. They had come here, to the closest medical clinic, driving as fast as they could over the bumpy road, and still the trip had taken almost three hours.

We had heard that the doctor was away. The police station was nearby and we suggested they go see if the police had better information about the doctor's whereabouts. They were back in minutes to report that the police had no medical supplies, no idea where the doctor was, and no suggestion other than to go see the white people who were over by the store, namely us. We told them that two more hours of driving would take them to the well-staffed hospital at Opuwo. The other option was to wait at the clinic and hope the doctor returned soon. The woman in the back of the truck continued to wail, and a baby was crying. One of the policemen walked up to tell us that the police had a car but no gas. He seemed confused and kept asking us what we thought should be done. We gave the driver directions to the hospital, assured him that the road ahead was better than the one they had just traveled, and sent them off. The shadows were growing long in the late afternoon light and they would be lucky to make Opuwo before dark.

Going to Town

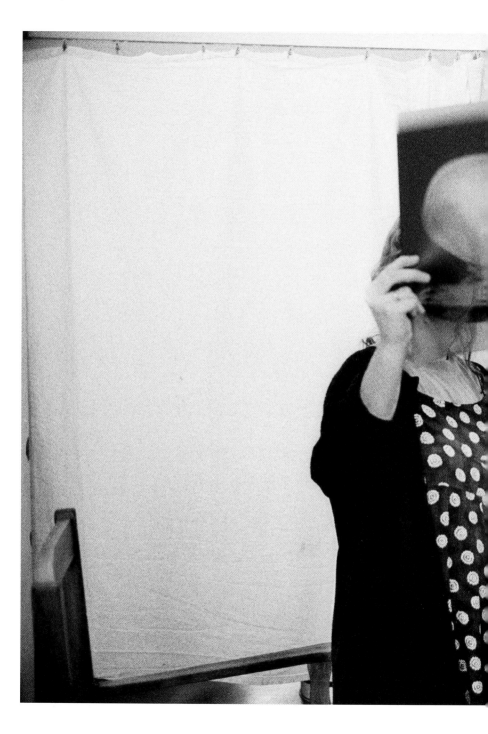

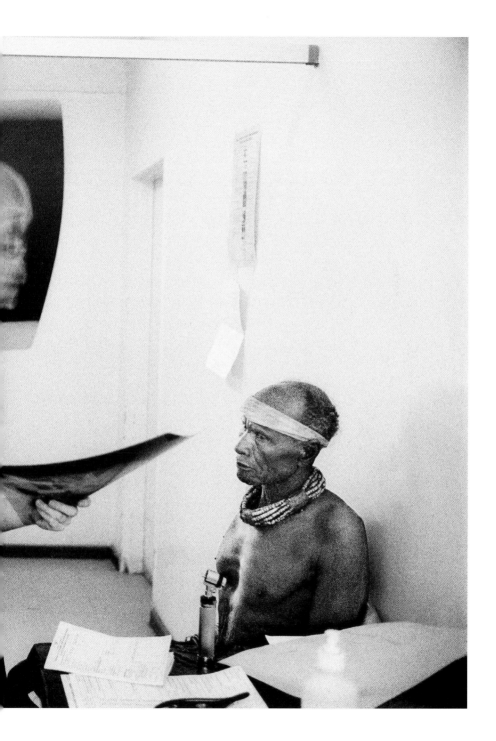

The hospital was why people went to Opuwo. We returned to the town ourselves a few days after the sick woman was transported there, and met a young doctor from Scotland who told us there had been a survey done that found most trips to town were for medical treatment. The town had been an important South African military base during the war and the large hospital was part of what was left of it. The Scottish doctor took me on her rounds one morning and together we walked the halls of the rambling building where shiny modern medicine lived side-by-side with third world improvisation.

It was strange to see the men in blue flannel boxers, their walking sticks resting against metal night tables. One man had a shoulder injury and several were being treated for tuberculosis. We saw a baby who had rolled into a fire and burned his stomach. He was lying on a stained foam mattress and his mother, who wore a green hospital smock over her ochre-stained body, was staying on the floor next to him on a couple of blankets. The baby screamed when the bandages on his tummy were taken off, revealing a burn that still seeped red in places, though much of it was pink and dry. It's healing, the doctor said, satisfied.

The doctor told me that many of the burns on adults were alcohol-related. They tended to be deep burns because, after falling into the flames, people would lie there, too drunk to respond quickly. The clinic in Etanga had been closed when we were camped there under the meeting trees and anyone with an injury had come to see us, knowing that white people always travel with medical supplies. One afternoon, a man had arrived with a seeping wound on his leg and one on his elbow. The school boys started to snicker and said the man had fallen into the fire when he was drunk. David asked the man if the accident had happened when he was drinking and the man had smiled and nodded.

It was a Monday morning when I teamed up with the doctor. The lineup outside the hospital was long; people leaned against the concrete, leaving ochre stains. The hospital was only open for emergencies on the weekend, so on Monday people arrived early and spent the morning waiting to be seen.

CLEAN

Most of the foreigners in town lived in the ranch-style homes that had once housed South African army officers. Most of the front yards were dry grass and dust now, and many of the back yards held empty swimming pools with cracks in the concrete. The friendly Peace Corps volunteer from Colorado lived in a faded house in the middle of the block. His name was Gary and he had invited us to stop by his place anytime we needed a shower or a place to stay.

Gary said he had been in Opuwo long enough to know that travelers were good entertainment; the foreign community was small and split between the missionaries who tended to keep to themselves, and a few dozen aid workers, teachers, doctors, nurses, and engineers who sometimes gathered for parties. Gary ran the youth center and was proud of what they had set up for the local kids, but was under no illusions about the significance of his efforts. He gave the kids a place to hang out, play games, watch the only TV most of them had access to, but said he wasn't improving their chances of getting jobs in this marginal economy or reducing the likelihood that they would wind up drinking. He was distressed about the future of these kids, but in a resigned been-too-long-in-Africa kind of way.

We were in Gary's place to take up his offer of a shower. While David and Gary talked, I shifted in my seat and became conscious of the walls around me. After several weeks of living outdoors, I was now back in the enclosed world. The flies lived on the far side of the glass, and the trousers I'd been wearing for the past week belonged out there too. My fingernails were caked with dirt, my hair smelled like smoke. Among people who spend their lives outside, stains and odors are normal; there is a lot of space, the wind blows, and odors don't get concentrated like they do when unwashed bodies are contained by walls. Opuwo was an outpost of the inside world. Gary was cleanly shaved, and wearing pressed clothes that didn't stink from a week in the bush.

The deep porcelain tub looked promising but it took half an hour to run five-inches of tepid grey water; the bath left me smelling like shampoo, and contemplating the effort required to maintain the norms of the center out here on the periphery.

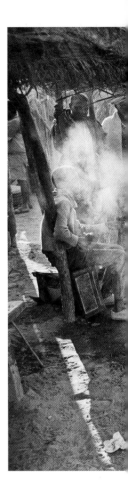

Market

People coming to the hospital were usually accompanied by family members who hung out in Opuwo until the patient was ready to go home. Most people passed the day in the market where freshly killed goat and beef hung from hooks in open air stalls protected from the sun by palm frond roofs. Women knelt over small fires cooking bread and meat and offering it for sale. Buildings made of mud bricks lined one side of the market; they were dark little bars that seemed always to be open and usually to be full. The market was crowded and sometimes the bars spilled out and the whole lane would fill with exuberant drinkers.

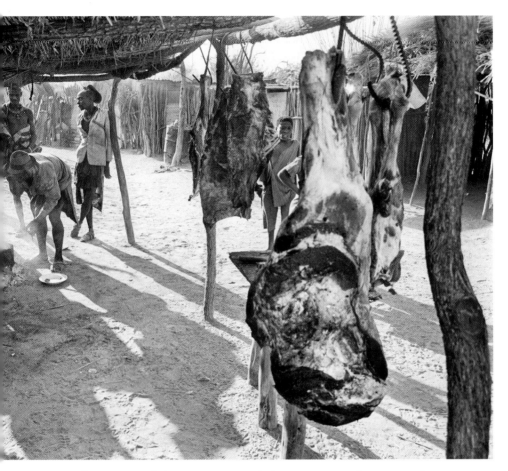

At such times, I tended to gravitate towards the women, crouching next to them, sharing peanuts and playing with their babies. Unlike the braided hair of Himba women, mine was forever blowing around in the wind. Often ochre-stained fingers would reach up to my face and one of them would pull strands of hair from my mouth with an indulgent fussing look.

At other times the women were in the middle of the drinking. One afternoon, we spent an hour in the dim interior of a small bar. Some excellent pieces of Himba jewelry hung over a string on the back wall; things people had sold to the bar in

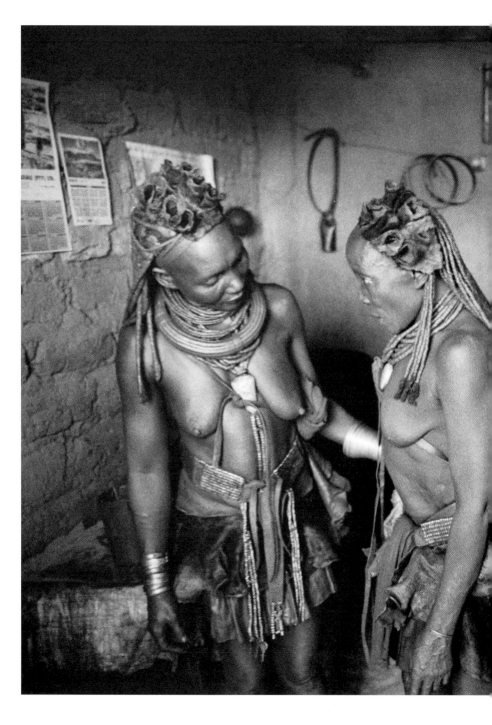

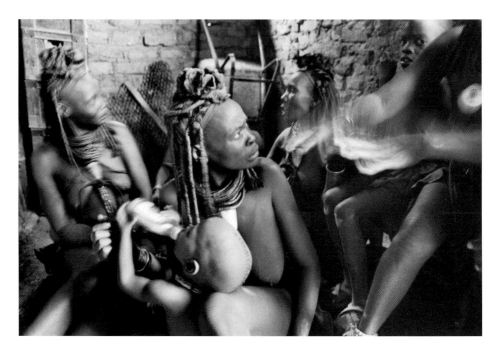

exchange for beer. A group of women were passing a bottle and arguing loudly. One of them was breast-feeding her child; when she got drawn into the argument, she stopped breast feeding and her baby grabbed for the bottle.

SUBURBS

The center of town still resembled a military compound, but on the outer edges there was a burgeoning suburb of mud brick houses crowded together on crooked streets. Morning fires burned in outdoor kitchens. The lanes were narrow and full of people, goats, and the odd chicken.

On a barren stretch of ground beyond one of the suburbs, we found two Himba huts. At our feet lay a discarded sneaker, bits of broken plastic, and pieces of paper. The huts fit in with the trash. They were traditional Himba dwellings but wrapped in pieces of plastic and cardboard. An old man with shockingly thin arms and legs was hunched over in front of one hut. The scene reminded me of what we'd heard about

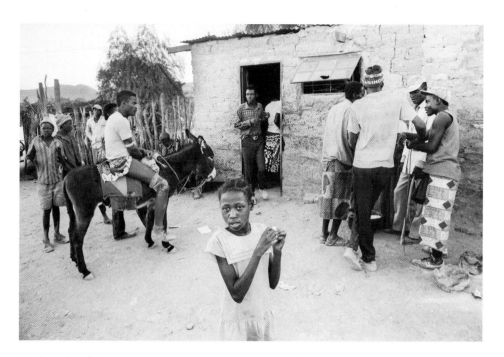

the drought of the mid-'80s when the death of their herds brought many Himba to town where they built shanty huts out of cast-off materials and survived on handouts from the government.

Several women were sitting nearby on a piece of cardboard, and one of them was reclining while the other two braided her hair. Braiding is a time-consuming process that involves twisting pieces of hair with ash. The women's actions were unhurried. Though we had been alarmed by the appearance of the old man, from what we could gather from the women, he was simply very old. This camp on the outer edge of town was primarily a place to stay while waiting for relatives who were receiving treatment at the hospital.

AIDS

Doctors at the hospital had just confirmed their first local HIV case. The man was not a Himba, but the doctors knew it was only a matter of time. The communality of the

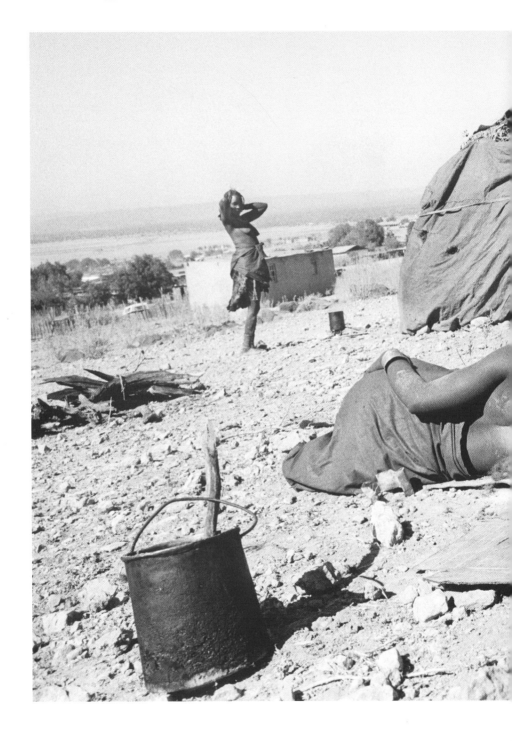

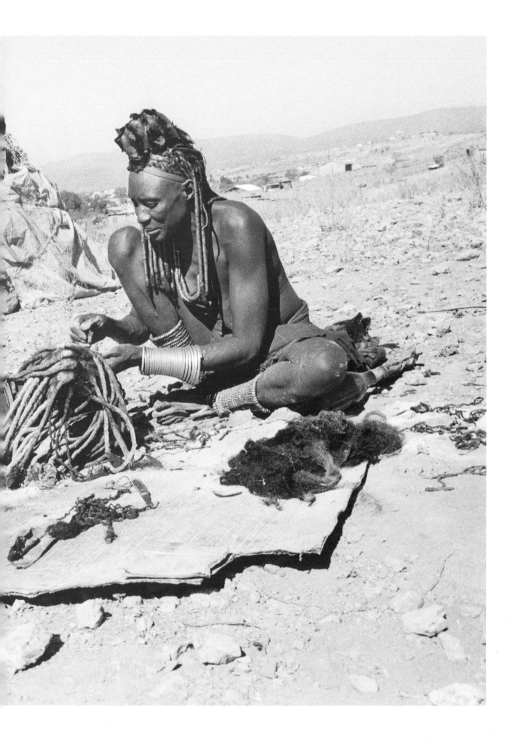

Himba extended to sex. While most adult Himba had spouses, they also had lovers. It was standard practice for a man, if he was not home by evening, to stay away for the night so as not to surprise his wives with their boyfriends. Gonorrhea was common and young men wore their first gonorrhea treatment like a badge, proud of the fact that it declared them sexually active.

The taboo against having sex with anyone outside the Himba community was still strong, but alcohol and the tribally mixed environment of the market was helping to break it down. One doctor spoke about the mobility of the Himba and the potential for spreading the disease. "None of them stay in Opuwo," he said. "They may come here for as long as six months, but they always go back to their villages."

At a dinner party of Peace Corps volunteers and NGO workers, the Scottish doctor related her efforts to educate her Himba friends about AIDS. "AIDS is a great tragedy that will affect all of you soon," she had warned.

"We have many horrors," they had responded with customary fatalism. "The war, the drought, so AIDS is next. That is normal. There is always some terrible thing about to happen."

VIDEO

The dinner party was at the home of a teacher from England and the dozen foreigners were struggling to keep a conversation going until the subject of tourists came up. Everyone laughed at how inaccurately the tour brochures depicted things. The Scottish doctor told about the in-flight travel video she had seen while flying back to Namibia after a recent visit to Scotland. The video had explained that the Himba belonged to a primitive tribe, that many of them had never seen white people before, their language had never been written down, and that in order to speak to them, the film crew needed two translators. The video footage had panned across a village and then moved in on the headman who, according to the translation, said, "We are so happy to have you here and are glad you want to see how we live."

The doctor laughed as she told us this. In her year at the hospital she had learned the Herrero language and come to know many of the people who lived close to town. The

video footage was from a village on the main road, one she had visited many times. The headman shown on the film came to see her at the hospital almost every week. In the video, his words had been translated from Herrero to Afrikaans and then into English, but the doctor listened to the Herrero and did her own translation. What she heard the headman say was, "I don't understand why you are here. You used to live like this once too. And who is getting the money for this anyway, because I haven't been given any."

SHOPPING

Men were always asking if they could have our dog. David said it was because they thought he would keep jackals from stealing their goats. One afternoon a man drinking beer insisted I sell him the dog. I told him I would trade the dog for a cow, knowing that the price for a cow in Opuwo was $1,000. He looked shocked and then laughed and laughed, saying a cow was too much to pay for a dog.

Another day a young man approached me, smiling and friendly. He spoke English and wanted to sell me a bracelet made out of plastic piping. I told him I didn't have money to spend on jewelry and his face turned ugly. "If you don't have money, why did you come here?" He waved his hands, angry and disgusted, as if to brush me out of the market. We were near the clothing store, piles of second-hand clothes spread out on a large tarpaulin – overcoats piled next to T-shirts and jogging suits. Nearby, a woman was buying school clothes for her daughter. The mother wore a goat skin skirt. Her daughter no longer wore braids over her face; instead her hair was cut short. The dress her mother picked out for her was blue with white polka dots. I wondered where it had been made. The brand names of the piles of clothing seemed to mean nothing to the women shopping, but they resonated for me. Sweaters from Smart Set, Daniel Hechter, an Izod Lacoste golf shirt, and on one unhappy-looking woman's head a scarf with the famous interlocking "C"s of Coco Chanel.

The men in the market wore T-shirts from all over the world: Milan International, West Virginia, the Paris Dakar Rally. One from Hash House Indonesia caught my eye; the boy wearing it was buying a flat of Cokes. I watched him walk away and wondered what the shirt meant when worn by someone who couldn't read and didn't know what

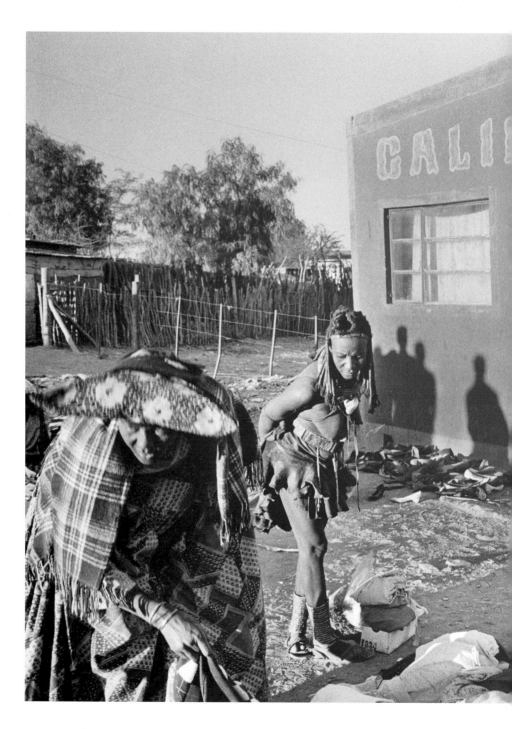

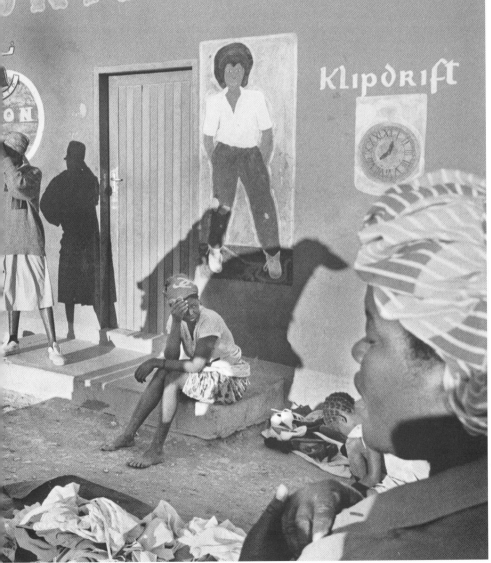

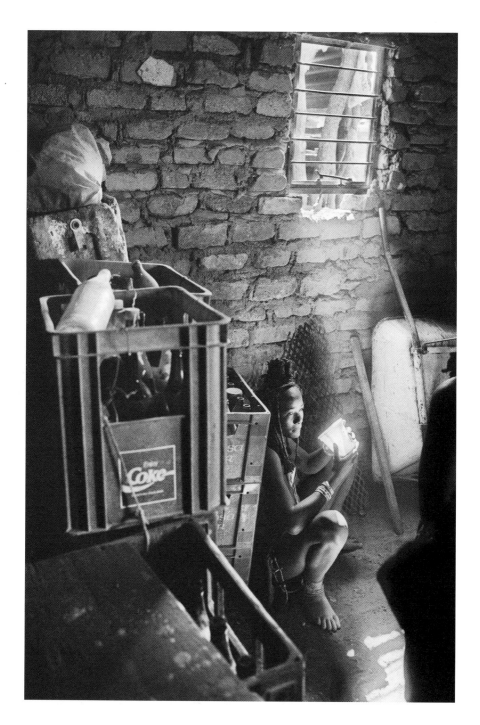

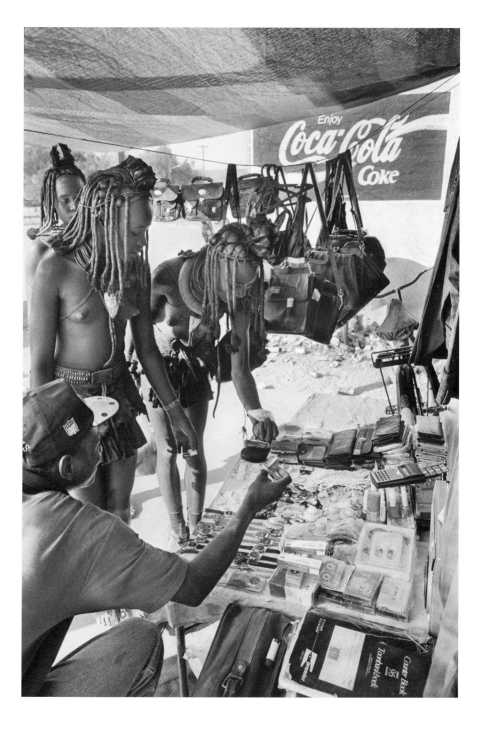

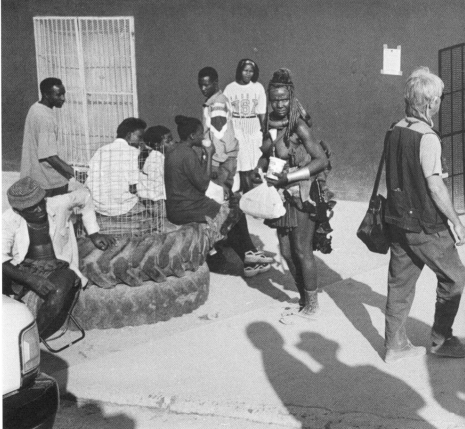

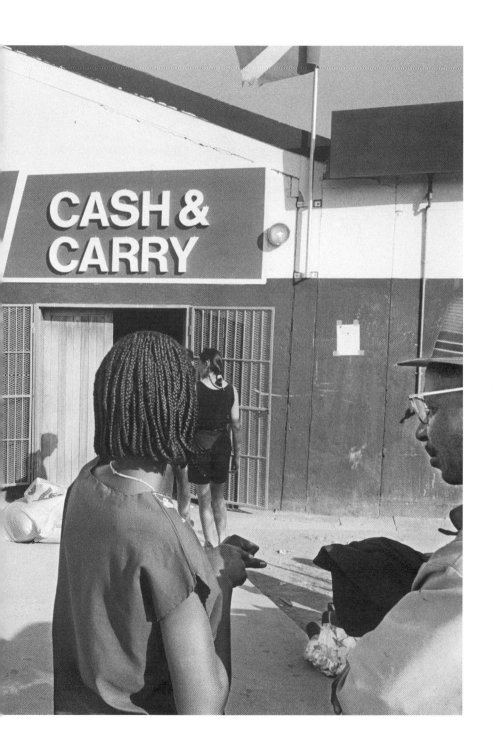

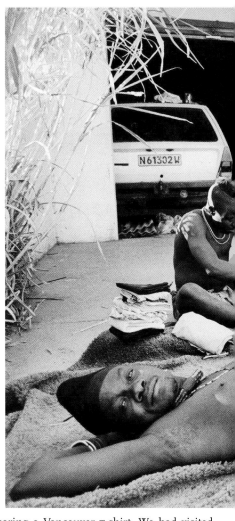

Indonesia was. Another teenager was wearing a Vancouver T-shirt. We had visited friends in that city before leaving for Africa, and the words on his chest gave me a bitter-sweet feeling. I asked him if he knew Vancouver and he shook his head. I told him it was a city in my country, and he looked at me blankly. At one time the T-shirt was probably a souvenir of somebody's trip. Its meaning was different now. T-shirts were something the men seemed to be proud of, like their wristwatches.

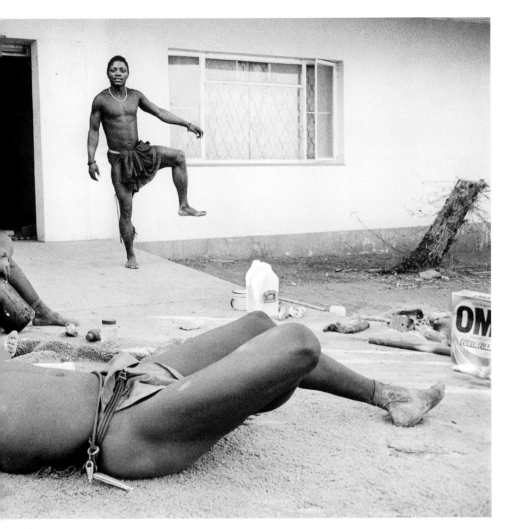

Soap

One afternoon, we came across three young men washing their t-shirts in the front yard of a house. They were using an old ammunition case as a makeshift washtub. They had a box of laundry soap and once they had finished with their clothes, they used the soap on their bodies.

The evangelical preachers exhorted the people to wash themselves, put on clothes,

and come to Jesus. We had received many requests for soap, usually from men. Women were given soap when they came to the hospital, and asked to wash off their ochre. They had to wear green hospital smocks over their bodies, and paper towelling wrapped around their braids so they didn't stain everything. Traditionally, the women "wash" with the paste of butterfat and ochre which they rub into their skin each morning. But the ochre leaves stains. When Karamata's wives rode in the back of the truck, their headdresses left marks all over the ceiling of the canopy, and the foam mattress we slept on was never clean again. The women rub off on the world around them, which wasn't a problem with tree trunks and stones around the fire, but isn't great for upholstery. I read recently about two women who said they had stopped using butterfat and ochre and wore dresses instead because white people didn't like giving rides to women who stained their cars.

Photos

When tourists pulled into Opuwo, their first stop was usually the gas station or the PowerSave, both popular places for Himba to position themselves for photo opportunities. One morning in front of PowerSave, an air-conditioned bus pulled in and let out its load of middle-aged Europeans. A couple in khaki made a beeline for me, the only white person in the vicinity. They were friendly Brits who wanted to photograph the Himba and were concerned that they do it in a way that didn't upset anyone. I explained that taking photos was a matter of asking permission and negotiating a price.

They approached two women who were standing nearby and gestured with their cameras. One of the women held up four fingers and said, "Dollar." Other members of their tour group saw what was happening and went over to the women too, forming a line and one by one pointing their cameras at the bare-breasted women, paying them, then heading back to the bus.

These encounters were usually awkward. There was a role reversal here, one of the few exchanges between Himba and foreigner in which the burden of desire rested with us instead of with them. There was a measure of nervous tension on the part of the picture taker: exotic photographs are an important part of a successful vacation, and the Himba were exotica that talked back and asked for money.

Tourists often took pictures without saying a word to their subjects; the only eye contact came through the viewfinder, the only physical connection the coins in outstretched hands. I wondered how it had come to be that getting pictures of these people was more important than actually meeting them. It seemed tourists came to take their own versions of the photographs they had seen in tour brochures and travel magazines.

GOSSIP

For weeks we had been hearing rumors about a French girl who had spent a year living like a Himba and written a book about it, one of those bestseller gone-native kind of books. The Belgian anthropologists said they had heard of a white woman who had stayed for awhile in a village near Etanga and dressed like a Himba. Gary thought that the Peace Corps volunteer he had replaced told him about a French woman who got stranded in the bush and ended up staying with the Himba. Nobody knew her name. I was skeptical about whether or not she existed until she showed up looking for me.

Her name was Solenn, she had just arrived from France, and someone had told her about the other foreigners in town who were interested in the Himba. She was young and pretty and the rumors were true. Three years before she had spent six months living with the Himba. I seem to recall that she had been traveling through the area, fought with her companions, and gotten out of their vehicle near a dry riverbed in the middle of nowhere. She had fallen ill and spent a miserable two days lying sick and alone until passing villagers found her, took her home, nursed her back to health, taught her Herrero, and gave her the name Girl Who Moves With The Wind. She had stayed in the area for about a year, coming and going from the village that had adopted her. That was in 1993 when the Himba were still relatively unknown. When she had returned the following year, in the wake of visits by Discovery Channel and *National Geographic*, the people had started charging for photographs. She was back now for the first time in two years and, when we compared notes, found that the price of a photograph had doubled since then, up from two dollars to four.

Solenn had been working with a geologist to organize the Himba end of a United Nations event honoring the year of indigenous peoples, bringing representatives from

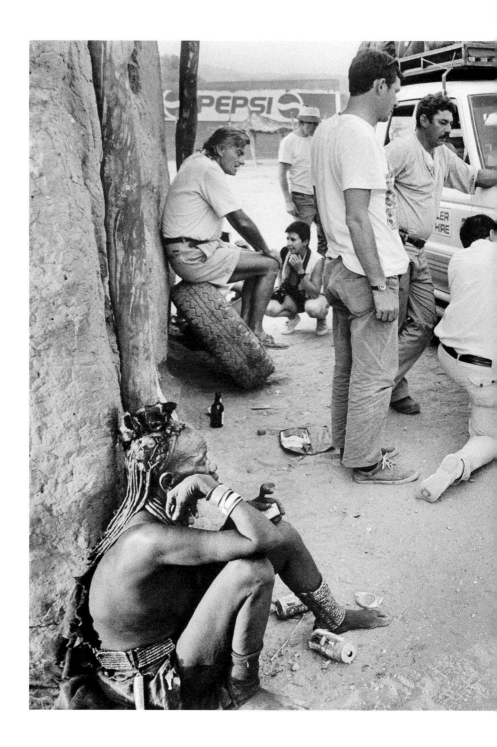

the Aborigines, the San Bushmen, and the Laplanders to visit the Himba. Kapika and the other headman had been consulted, and a village chosen for the occasion. The visitors had been due to arrive in the early evening and stay overnight. When Solenn and the geologist got to the village the next morning, it was deserted. They found everyone in the nearest town in the middle of a drinking party with the headman passed out. The geologist spent the day ferrying the villagers back to the village, while Solenn tried to sober the men up with ground corn and tea.

When the visitors arrived, the Aborigine woman tried to make conversation with the headman, commenting on the cattle she had seen. "No, there are no cattle here," the headman said. "We do not have any. But if you want to give us some, we need them." The more politically astute tribes tried to tell the Himba about their experience with dams but, Solenn said, the Himba wouldn't listen, repeating "We will die," and refusing to talk about it. At one point, the tribal representatives asked that all the government workers and missionaries in the group leave for awhile. Someone threw a cooking pot at a missionary and a fight had broken out.

I told her about our visit with Kapika and she laughed. "They are rich," she said, "and Kapika most of all." She speculated that it must drive the government mad that they don't pay taxes. But if they paid taxes, she said, then their farms would have to be recognized as legally belonging to them, as being their land.

DANCING

The wind was gusting and at the far end of the market, a group of women were clapping their hands and stamping their feet. Every few minutes someone would break into a solo while everyone else cheered. A woman in a long dress came and stood beside me. Her skirt was dirty, her eyes were mischievous, and she pointed at the dancers, suggesting I join them. I laughed and motioned for her to join them instead, and she did, standing in line with the clapping women for awhile before doing her own wild solo. When she stopped, she pointed at me, and held out her hand. I felt the eyes of the market turn our way as she helped me pick up the odd rhythm of the clapping, and pound my feet, heavy in hiking boots, into the ground.

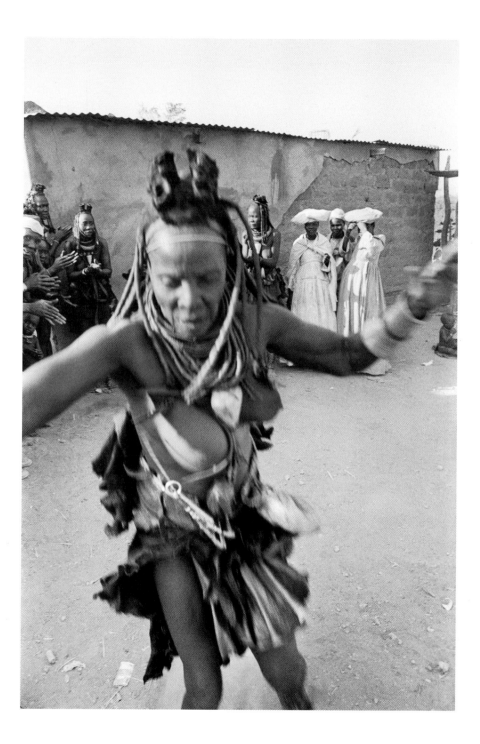

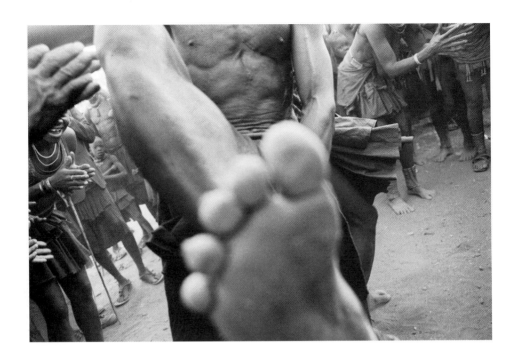

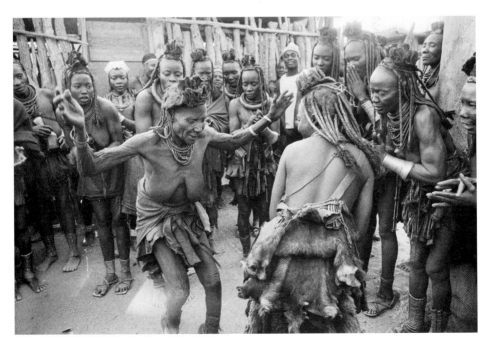

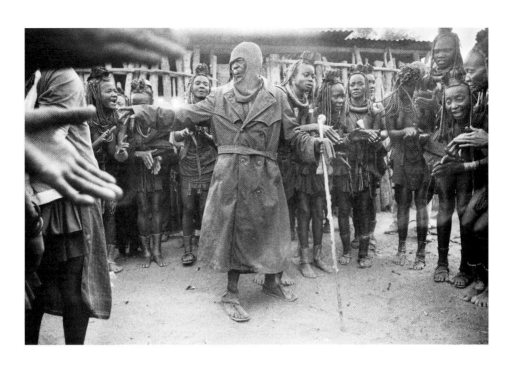

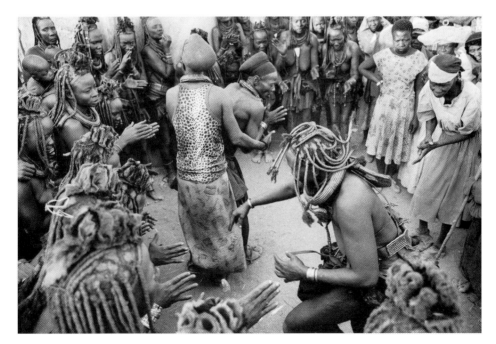

A local headman was watching and David asked permission to take pictures, and paid him the obligatory photo-taking fee. He asked if this was a special occasion and was told that the women were dancing because they were happy. More women joined and the line became a circle, men joined in and the volume rose. There was no order that I could discern, but everyone seemed to dance alone at some point. When a woman reached out and pulled the photographer into the middle, the crowd whooped with laughter.

FUTURE

The soft-spoken man was both a doctor and a missionary; he was from South Africa and had been in Opuwo for five years. His yard was one of the few where flowers grew and his living room was decorated with pictures of his many children. We spoke about health conditions among the Himba, and talked about what he had observed: there were no heart attacks, little hypertension, and no heart disease; it was things like respiratory infections and malaria that tended to kill people. He expressed concerned about the new health risks that a large dam would generate. The stagnant water would be a breeding ground for malaria-carrying mosquitoes and other water-borne illnesses, and the road improvements and influx of workers would bring more AIDS cases into the region and HIV rates were already high in nearby Ovamboland.

I told him about the drinking party at Epupa Falls and he shook his head. He said *okandjembo* was made from maize flour mixed with sugar that was left to ferment before being boiled and distilled. He talked about how the people used to make their own beer, and only had it occasionally, but now whenever the trader comes, people binge. The alcohol supply in Kaokoland was still sporadic, but he had heard of traders who traveled twelve or fourteen hours into the edges of the desert. He said *okandjembo* kills brain cells, which makes it harder to think clearly. He was seeing cases of cirrhosis of the liver and a condition called pellagra that results from a niacin deficiency people get when they stop eating and keep drinking. He told us the country's only detox was a three-day program in the capital.

I asked what he felt would happen in the future, and he reflected a moment before replying that he thought there was a wisdom in the Himba, an ability to reject pieces

of western culture. In his role as a missionary, he had spent a lot of time with several chiefs in the area and he talked about how they were refusing some aspects of our culture. He gave the dam as one example, and also talked about a headman who had asked for a school in his area, but wouldn't send his own children there, saying it was the lazy ones who were sent to school. I liked his hopeful perspective but couldn't get past the fact that the future was in the children, not in the old people, and the ways of the west seemed to be especially appealing to the young. I asked him about this and he said that, yes, the wise ones he spoke of were older men and the youth, he had to admit, seemed vulnerable and did not wear wisdom in their eyes.

He said that attendance at school was increasing and we talked about how kids who went to school didn't get a practical education in goat herding and were losing the expertise required to maintain the self-sufficiency of their ancestors. Instead, kids who went to school emerged literate, with skills suited to office jobs. The local economy didn't have many jobs to offer, and these kids were in an awkward place, no longer able to participate in their parent's world, often disdainful of traditional life, and yet unable to move ahead in our world either. The doctor thought that might be changing; he had heard recently of a young man who was selling insurance, and I wondered aloud if that was what the future looked like – a Himba insurance salesman.

Culture

We were picked up after supper by one of the students who had taken a liking to us. There was a cultural festival at the high school that evening and we were invited. Well-dressed townsfolk filed into the gym and filled the rows of chairs set up for the event. The festival began with a prayer, after which we watched the students perform military marches, dressed in white shirts and dark pants. The school choir sang and groups of students did the dances of different tribes. There were Herrero dances, Zemba dances, and two Himba dances, one by girls wearing yellow dresses, another by the young men who, I couldn't help notice, were all wearing either shorts or underwear beneath their skirts. The audience clapped at the end of each dance.

One of the final performances was a demonstration of the holy fire performed

by two young men wearing suit coats and funny hats. There was much laughter from the other students when they came in carrying a tree branch, laid it on the floor, and slowly sat down. The student who had brought us leaned over and told me they were pretending to be old men, and that was why everyone was laughing. The teacher who was running the event brought the microphone over, crouched down, and spoke in Herrero; the student beside me said he was explaining that the holy fire was where the old men talked to the ancestors. The ripples of laughter persisted as the two "old men"

shifted around and pretended to light the fire.

The evening ended with speeches from a community leader, but even before he got up to talk, most of the students had already slipped out of the auditorium. They were headed, my friend told me, for the disco down the road.

"Our traditions are our life," the speaker said to an emptying hall, "we must remember them."

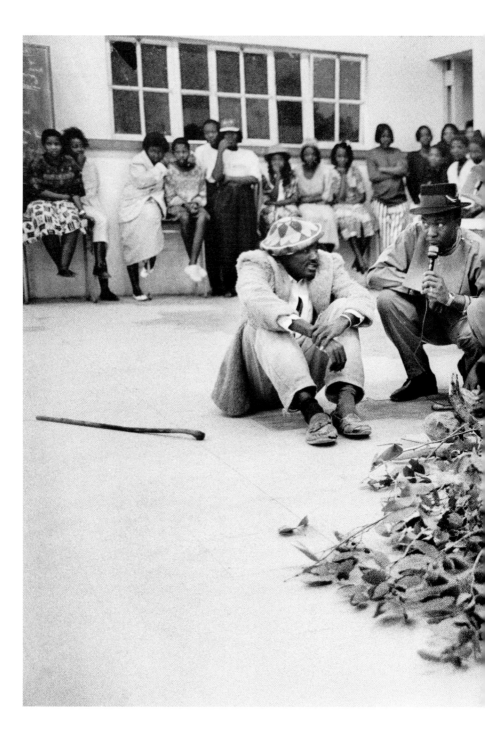

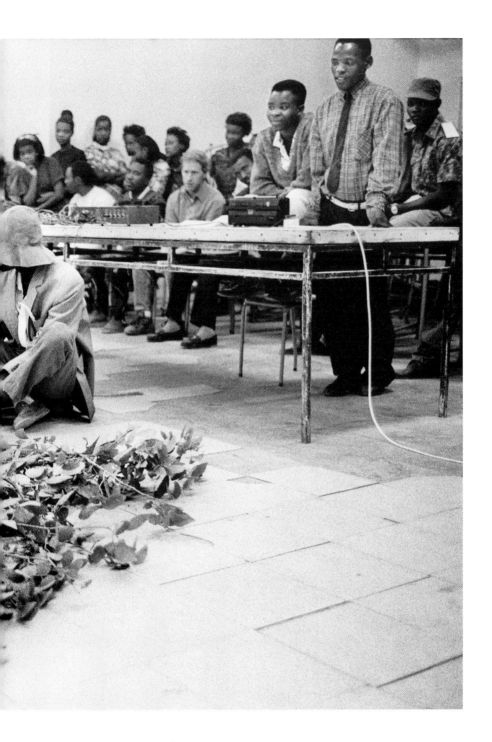

MONEY

When we finally added up the money remaining in the envelope under our bed, it wasn't enough to cover our gas back to South Africa, not even if we traveled the shortest route. Our credit cards had been dead for months and we had empty bank accounts on two continents. It was what I had feared would happen; we had given away more than we could afford and were left short in a place where all the other white people seemed to be flush. Outside the store in Etanga, a woman had laughed at me when I told her I didn't have any money. The old man next to her had said, "White people always have money."

We joked about selling the truck, buying some goats, and never going home. Then we decided to sell my camera. The closest store that sold electronic goods was a half day's drive away, so there was a chance somebody might want it. Within hours of conceiving this plan, I ran into one of the Americans who taught at the high school. He was with a young Namibian teacher and while we sat talking, she mentioned that on her recent vacation to the game reserve her camera had been stolen and she wanted another one. I offered to sell her mine and she paid me on the spot.

We went outside and I took a few pictures of the two of them, shooting off the last frames on the only roll of film I shot in Namibia, and handed over my camera. When David came back we packed up, drove out of Opuwo, and never saw another Himba.

Even as we counted ourselves fortunate to be in a place where people still spent time in the way the rest of us spend money, David and I couldn't escape the feeling that the future in Namibia had already been written. The story of contact between indigenous people and the "developed" world has been played out many times in the past few centuries. There are always variations, but the same themes have tended to repeat themselves. In the six years that have passed since we visited Namibia, the story of the Himba has continued to unfold.

Chief Kapika traveled to Europe within a year of our visit to tell politicians and television cameras about the dam proposed for Epupa Falls. His trip spurred environmental and human rights organizations to take up the cause of the Himba, and resulted in an international campaign against the dam and a strong lobby for the recognition of Himba land rights. Plans for the dam stalled in 1999 when talks broke down between Namibia and Angola about where on their shared border to locate it. The government is still talking about the project, but today the dam seems more rhetoric than reality.

At the Opuwo Hospital over the last two years, the number of people admitted with HIV symptoms, including some Himba, has risen drastically. AIDS has spread throughout Namibia and the country now has one of the highest HIV rates in the world (twenty percent of adults are infected). In an odd twist, the population of the country is expected to drop as a result of AIDS, and with it will drop the demand for electricity, which will further reduce the economic viability of a dam at Epupa Falls.

Late one night, while scrolling through a website for Christian missionaries based in Opuwo, I came upon a picture of a young man whom we had met at the anthropologists' camp. His name is Makuma and he was the son of the headman who had propositioned me. He is the young man holding the flashlight on page 13 of this book. In the photo on the website he is holding one of the solar-powered tape recorders the missionaries are distributing so the Himba can play tapes of sermons and gospel songs.

Two months ago, Namibia's daily paper ran an article about the Himba and the changes they are facing. The reporter visited a village along the Kunene River and

spoke with a woman there about how the people have adapted to new foods, let go of some of their nomadic ways, and are dealing with the threat of AIDS. The woman said to him, "If a person is dressed like me, you don't get AIDS. Those wearing clothes get it. They go to towns and get it there. That is where they also drink too much alcohol." She went on to tell the reporter about her daughter who goes by the name of Maria. She explained that Maria no longer wears traditional clothes, having stopped wearing them after the birth of her son. The woman was quick to point out that, while her daughter wears "township clothes," she is not HIV positive.

The photograph on the cover of this book is of a woman who lived along the Kunene and called herself Maria. At the time, she had a young daughter and was heavily pregnant with her second child. Maria's children are the future. Sitting in my inner-city apartment, surrounding by the sounds and smells of morning rush hour, I wonder what the bumpy road of development will mean for them.

– *Vancouver 2002*

List of Photographs

Appendix

The young French woman we met in Opuwo published her book the following year:

Bardot, Solenn. *Pieds Nus sur la Terre Rouge: Voyage Chez les Himbas, Pasteurs de Namibie*. Paris: Robert Laffont. 1997.

Some relevant titles from the growing body of anthropological writing:

Bollig, Michael and Jan Bart Gewald (eds.). *People, Cattle and Land: Transformations of a Pastoral Society in Southwestern Africa*. Cologne: Rudiger Koppe Verlag. 2000.

Bollig, Michael. "Framing Kaokoland," in Hartmann, Wolfram et al (eds). *The Colonising Camera: Photographs in the Making of Namibian History*. Cape Town: University of Cape Town Press. 1998.

Bollig, Michael (ed.). *When War Came the Cattle Slept: Oral Traditions of the Himba of Northwestern Namibia*. Cologne: Rudiger Koppe Verlag. 1997.

Crandall, David. *The Place of Stunted Ironwood Trees: A Year in the Lives of the Cattle-Herding Himba of Namibia*. New York: Continuum. 2000.

Van Wolputte, Steven. *Of Bones and Flesh and Milk: Bodily praxis, identiy and mobility among the OvaHimba of Northwest Namibia*. PhD thesis. Katholieke Universiteit Leuven. 1998.

Warnlof, Christofer. "Images and Dreams for Sale: Turning 'the Himba' into TV Drama." *Journal of the International African Institute* Vol 70 (2). 2000.

There are several photo books about the Himba. These two have introductions by Namibian anthropologist Margaret Jacobsohn:

Jacobsohn, Margaret with Peter and Beverly Pickford. *Himba: Nomads of Namibia*. Cape Town: Struik Publishers. 1990.

Watson, John. *Himba*. Cambridge: Cultural Survival Inc. 1998.

The Himba are featured in a growing number of films. Of note:

Ochre and Water. Directed by Joelle Chesselet and Craig Matthews. Cape Town: Doxa Productions. 2000. (see *doxa.co.za*) This film follows the Epupa dam dispute over a period of seven years; it has been receiving awards at festivals around the world.

Shake Your Brains. Directed by Rina Sherman. Windhoek: Low Tech Film Art. 2000. This film is about alcohol abuse among the Himba. Dr Rina Sherman is a visual anthropologist currently based in Etanga who is working an extended film project called *The Himba Years*.

Kin. Directed by Elaine Proctor. UK: Art Council of England/Bard Entertainment. 1999. This feature film, starring Miranda Otto and Isaiah Washington, received mediocre reviews but is of interest because it used Himba actors, among them Cornelius Tjiuma, the young man who translated for us when we visited Chief Kapika.

Further information about the proposed dam is available in these reports:

Corbett, Andrew. 1999. *A Case Study on the Proposed Epupa Hydro Power Dam in Namibia.* Contributing Paper to the World Commission on Dams. (see *dams.org*)

Burmeister & Partners. *Feasibility Study and Environmental Impact Assessment of Epupa Hydropower Scheme.* 1997. (see *burmeister.com.na/feasibility.html*)

On the Internet:

Internation River Networks has followed the Epupa dam situation and maintains a webpage with updates and links. (see *irn.org*)

The Namibian, Namibia's daily paper, has an excellent website with archives back to 1998 (see *namibian.com.na*)

The Red Cross launched the Africa Women's Initiative in July 2001 to develop programs at the community level that address the urgent health needs of women and children, especially HIV/ AIDS. One of the pilot projects has been implemented in Namibia and includes the Himba. (*see redcross.org/services/intl/initiatives/africa/namibia.asp*)

Survival International, an organziation that supports tribal people and helps protect land rights, offers information sheets on tribal people around the world. They have one on the Himba. (see *survival-international.org*)

Acknowledgments

We are grateful to the Himba people we met for inviting us to join them by the fire and tolerating our questions, photographs, and persistent interest; especially Maria and Rampatoka, Karamata Mutambo and family, the children at the Etanga school, Kanguti, and Cornelius Tjiuma.

Our parents, Clair and Rochelle Shields, and Colin and Mo Campion, provided much appreciated love and financial support, and we offer a special thanks to Mo; we so wish you were here to see the end result. For flights of fancy, we remain indebted to Karen Connelly. Precious moral support that often included supper and a place to sleep was provided by Max Bastard, Katya Lyall-Watson, Alex Dodd, and Matt in Cape Town, by Tinkie Malan (pharmacist extraordinaire), Monique Steyn, Derek Knowles, and Brother Nick in Mafikeng, and by Heather Malek, Bill Damer and Noreen Branagh and kids, and Finbarr Wilson in Canada.

The enthusiasm and expertise that Hugh Brody and Stephen Osborne brought to this project were greatly appreciated. A grant from the International Center for Human Rights and Democratic Development made the journey possible, and the Banff Center for the Arts provided a quiet cabin where an early version of the text took shape.